Life
After
Birth

Life After Birth

Portraits of
Love &
the Beauty of
Parenthood

Knix and the Carriage House
Birth communities

Introduction by Joanna Griffiths
and Domino Kirke-Badgley

Foreword by Ashley Graham

Contents

Introduction

Welcome to *Life After Birth*. Whether you're expecting, you're ten days (or ten years) postpartum, or you've simply come here to wonder at the beauty that is birth—we've created this book to help build a beautiful community full of sacred stories that normalize, celebrate, and honor postpartum experiences.

Life After Birth didn't start as a book, but rather a photography exhibition in SoHo, Manhattan. The energy of opening night was unforgettable. The anticipation and nerves as we set up were running at an all time high. *What would people think? Would it speak to them? What would become of this little passion project and message we needed the world to hear?* Never in our wildest dreams could we have anticipated the response. There wasn't a dry eye in the house—ours included. People spent hours combing through every photograph, reading every caption and reflecting on every story. It was immediately clear that every postpartum journey photographed was a window into the contributor's soul, and people were genuinely drawn to these experiences. We knew we succeeded. We had built a connection; we had built a community.

We created this project to change society's postpartum narrative. Magazine headlines are dominated with stories of celebrities "bouncing back" and maternity leaves are shorter than ever. We talk about the "fourth trimester"

but in doing so, are limiting that part of the journey to a mere 12 weeks.

We believe in a different postpartum experience. What if instead of viewing postpartum as a matter of days or weeks or months, we honored the experience for what it truly is and recognized that we are postpartum *forever*?

We believe that the power of storytelling can help us change this narrative.

We're two individuals connected to the birthing world in very different ways. One of us, Domino, is a long-time doula and the other, Joanna, is the Founder & CEO of Knix—an intimates brand that sells maternity and postpartum necessities. And although we come from distinct worlds, we found the same disconnect in the messages that were being shared when it came to postpartum life.

In Joanna's case, nothing she had read, seen, or uncovered had prepared her for her first time giving birth, and more specifically for her life after. Domino had seen this time and time again as

a birth worker. A large part of her role in supporting new parents is managing the unrealistic expectations society has put on them, specifically the feeling that they have to "do it all"—be it hosting in-laws or the pressure to get life back to "normal."

Through both of our experiences we understood one thing: that in pregnancy, the emphasis is often on the impending arrival of the little one (or little ones), but we so quickly forget that in those precious few moments of birth, you're introduced to someone entirely new. And it's not your baby—it's you.

In many ways, this book follows the path of the exhibition that started it all—a journey through hundreds of stories that takes you down the beautiful, messy, humbling, and transformative road that is life after birth. Some of the women depicted in these photographs tell their own story, and some stories are in someone else's words.

We begin by honoring that every birth, and the path to that birth, is different. Whether your fertility journey was straight and direct, or you had to take

more of a winding (and often painful) path, everyone enters into this chapter with their own unique set of lived experiences. Every birth is different as well. Home births, hospital births, water births, car births, with a midwife, with an OB, with a doula. Vaginal birth, cesarean births—all of us have incredibly personal journeys. *These stories of new beginnings remind us to honor all the strength it took to get here.*

We reflect on the first precious few moments of life before moving toward memories of healing at home. *These stories teach us to be kind to ourselves in the early weeks of this long, uncertain, and beautiful journey.*

From there we explore feeding with love, which for many can be one of the largest and most challenging transitions. Through feeding pillows, bottle-feedings, nipple shields, feeding tubes, formula, and pumping, new parents stop at nothing. *These stories about nourishment remind us to be resilient. They remind us that we are uncompromising when it comes to those we love.*

We then transition into stories of ever-changing postpartum bodies, and how those transformations are not only physical but emotional and spiritual as well. *These stories teach us to worship the infinite growth and evolution within ourselves.*

Finally we take you through the journey of work-life rhythm. Any parent can tell you that work-life balance is not a thing—but rather, there are different beats and tempos in life. *These stories teach us that within the chaos, part of the magic is finding ways to make it work.*

We hope you find connection and comfort in these stories from contributors from all over the world. We are so incredibly thankful to the more than 750 people that submitted their journeys to us. You brought this beautiful project to life. A special thank you to Christy Turlington, Amy Schumer, Jillian Harris, and Jemima Kirke, who trusted us with their stories and came on board when this project was just an inkling of an idea. And, of course, we are especially grateful to Ashley Graham for her beautifully honest foreword.

One of the magical things about putting this project together was that we had no idea what to expect. But one thing became abundantly clear very early on— that the postpartum journey brings out a different side to who you are. It unlocks newfound strength, patience, love, and resilience that you likely didn't know existed.

And that's the beauty of being postpartum forever—you get to take all of these transformative moments, teachings, and experiences and keep them with you on every other journey life throws at you.

Sincerely,
Joanna Griffiths and
Domino Kirke-Badgley

Foreword

My son was born on January 18, 2020. A week later than his due date.

My first contraction happened at 5 a.m. I woke up moaning. Not in a sexy way. It was more like an agonizing, I-think-this-is-labor kind of way. After two hours, I woke up my husband, Justin, and made him clean our apartment. At 9 a.m., we went for brunch where I had contractions between bites of pancakes.

By Ashley Graham

When we went home, I climbed five flights of stairs sideways. The midwives said they would open up my hips. (A piece of pregnancy advice: always listen to your midwife.) Sure enough, my water broke 15 minutes into my at-home yoga class. It was not pretty. My pants were soaking wet. I dribbled a little on the yoga mat. After I was done crying from a hardcore contraction, I asked my husband, "Will you smell it? Is it musty?" (I had heard it smelled different from pee! He refused to indulge me.)

And with that, our labor journey began. I moaned and paced in just about every corner of our Brooklyn apartment. Five and a half hours later, I moved to a birthing pool in our living room. It was me, my husband, my midwives, and my doula. I was on my back. My knees were up. I was screaming. My feet were pressed into my husband's stomach. I was pushing. I yelled, "Progress!" My husband looked at me with tears in his eyes.

"Baby," he said, "I can see his head."

With those six words, I gathered the strength to push him out. A moment later, my son was on my chest. He was looking his dad in the eyes. It was like we recognized him, and he recognized us. "We're a family forever now," I told them.

In the same way there are many body types, there are countless birth stories. Mine is just one of them. Some happen in hospitals; others, if you're like me, occur at home. All of them are beautiful and all of them are right for that mother bringing her newborn into the world.

That's why this book is so important. In a society where we're expected to be perfect mothers, where everyone sets their unrealistic expectations upon us, the Life After Birth Project makes space for our experiences. Through intimate photographs, it shows the hard, beautiful, painful, glorious, life-transforming event of giving birth. More importantly, it allows us mothers to share our stories in our own words.

My pregnancy was a journey—my new body, learning to practice what I preach by being kind to myself, and the life-changing birth experience—today I can stand strong and say, "Wow, I did it. I'm so proud of myself." I want other women to have that exact same feeling of being invincible, because trust us, you are.

I'll let the other strong, resilient women featured in this book tell you their stories, but I'll leave you with one more thing. After giving birth, I know there is nothing I can't do. After all, I went through laboring for six hours naturally at home. In a big old pool. (Amazingly, our white furniture is still white.)

First 24 Hours

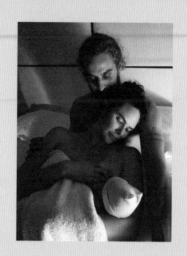

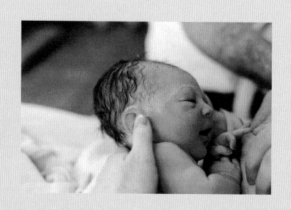

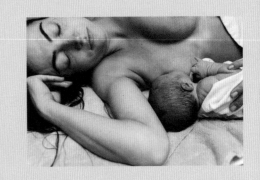

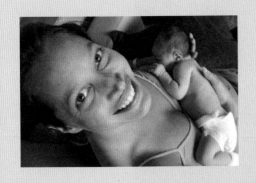

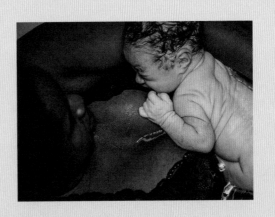

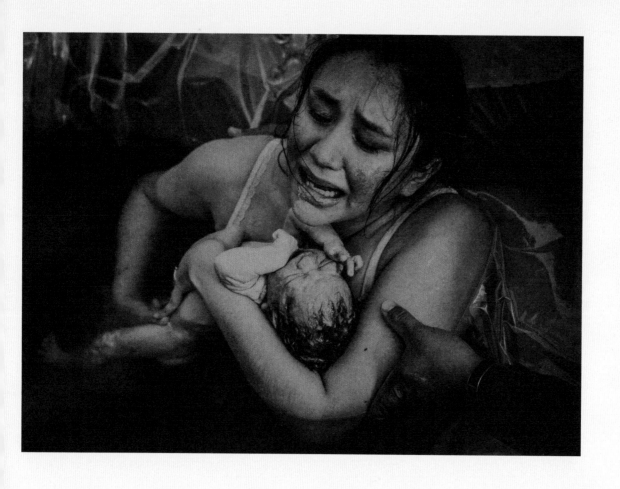

This is the epitome of love. Giving birth is like walking through hell and making it out the other side holding the purest of love. I went 41 weeks and 3 days with this pregnancy—it felt like it would never end. I had a heavily medicated birth with my first born. An unmedicated birth, trusting my body knew how to birth, was a priority this time around. Finally getting to hold him and accomplishing the birth I envisioned for myself, will always be one of the best days of my life.

Arelys
Hernandez

Kristen Watts Shelton

Transition. Baby was coming quickly. Her strength was inspiring. The room was quiet until she powerfully roared her baby boy earth side in the tub behind her.

—Ally Zonsius

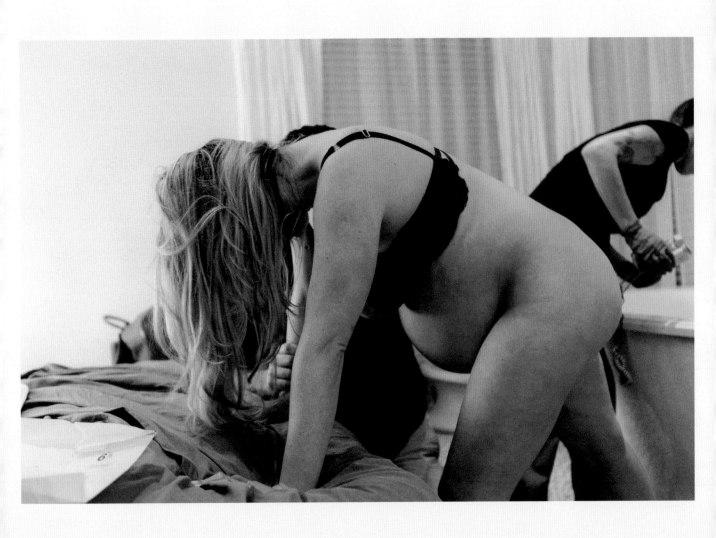

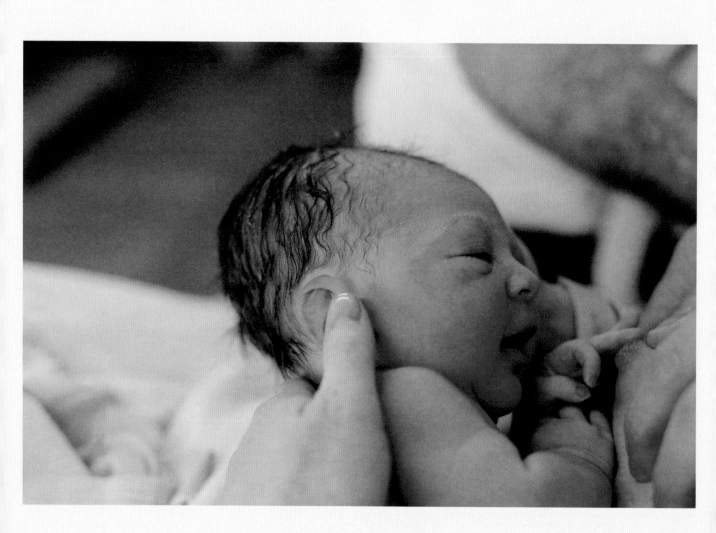

Learning to nurse. We do it with every baby we birth. Even though the world is unfamiliar to this baby girl, the smells of her mother's breast are nothing but familiar.

—Ally Zonsius

Hannah Judah

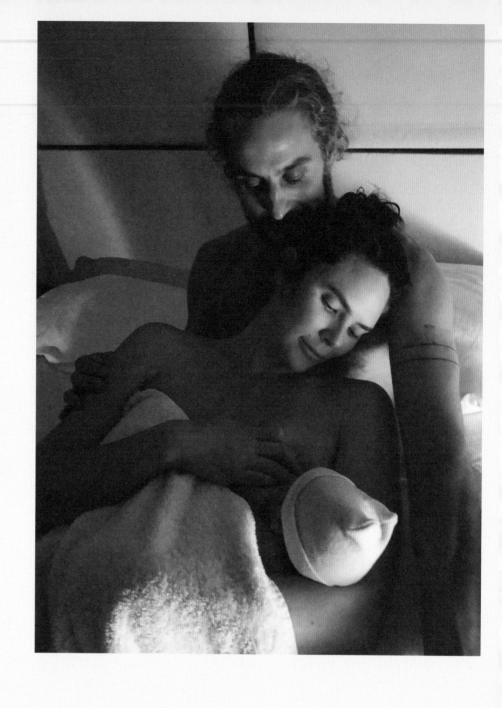

Amanda
Chantal Bacon

This was minutes after birthing her in the tub. My placenta was still inside. We moved to the bed because my midwife was worried about hemorrhaging and her assistant hadn't shown up yet. She came out in twenty seconds, one push, after a few hours of painful labor. It was the most pain I've ever experienced, but I wasn't afraid or ever suffering, I just took it moment by moment and managed. This was the birth I had dreamed of after a hospital transfer with my son eight years prior. It was the greatest moment of my life. It was also the moment that I lost the relationships as I knew them—with my son and husband. I did forty days at home and it healed me in unimaginable ways. I'm coming out of the fourth trimester now, feeling strong, capable, in love, sometimes sad about the harmony we've lost as a threesome (my son, my husband, and I), and missing the luxury of time and deep connection with my husband. But, everything is right on track and it's all about surrender and adaptation after birth.

Amanda Shuchat

I wonder if I would have felt any different when I met you, had I not had to fight so hard.

Would I have felt different if I got—and stayed—pregnant easily? If it didn't take three long years? Or if I hadn't had to master the art of sticking myself with IVF needles? Would I have felt any different if a surrogate carried you instead, the way the doctors said was our only option?

What if I didn't have a 17-hour labor and the subsequent C-section scar to prove it?

What if I never experienced the crippling nausea and growing belly? The heartburn caused by your full head of dark brown hair?

Maybe I would have felt different, maybe not.

But one thing I know is this: I would not have felt any less.

How you got here is a part of your story, and mine, but the outcome is exactly the same. A love so big it took my breath away, just as you took your very first.

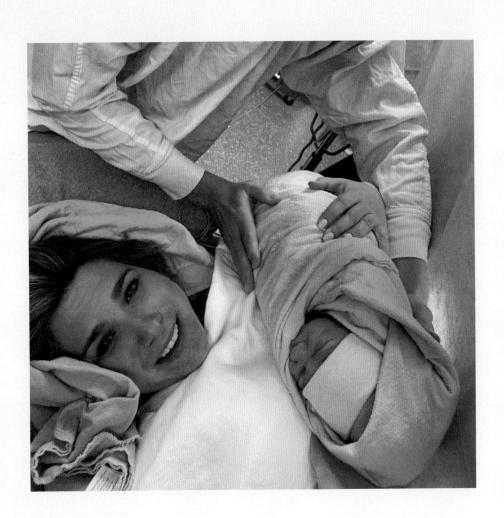

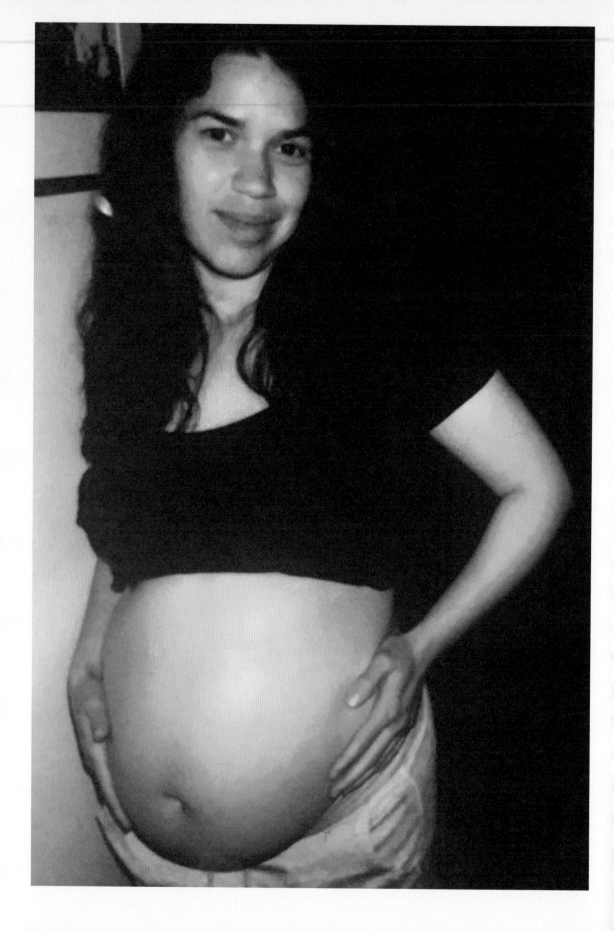

America Ferrera

As this baby grows inside and I attempt to breathe through the fears and unknowns of this time, I am thinking of all you other mamas bringing new life into this world right now. And also of all the women across generations and centuries and borders who have and are currently birthing new life in the midst of so many extraordinary and daunting circumstances. Life is a miracle, and mamas make it possible through their strength and power. Hang in there pregnant mamas! We got this.

Amy
Nelson

I welcomed four baby girls into the world in four years. It's hard to describe the hours and days and weeks after a baby joins your family and world. There is so much that is new and beautiful—and also so much that is new and painful. I've felt my body expand and contract with each pregnancy, and found a different normal every time. I talk so much about this duality—the beauty and the pain, the joy and the hard parts—with my friends. I wish our always busy culture recognized it more and gave new mothers patience and grace.

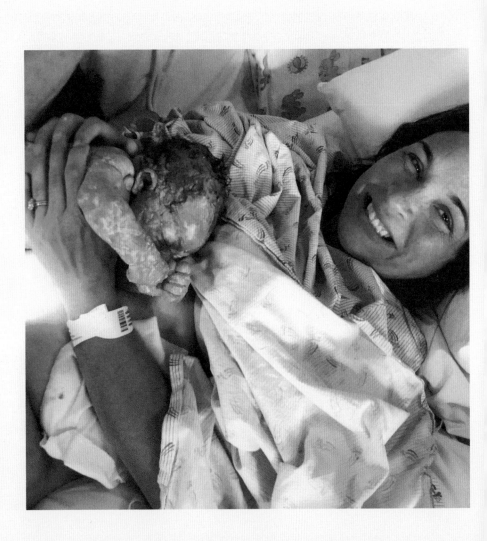

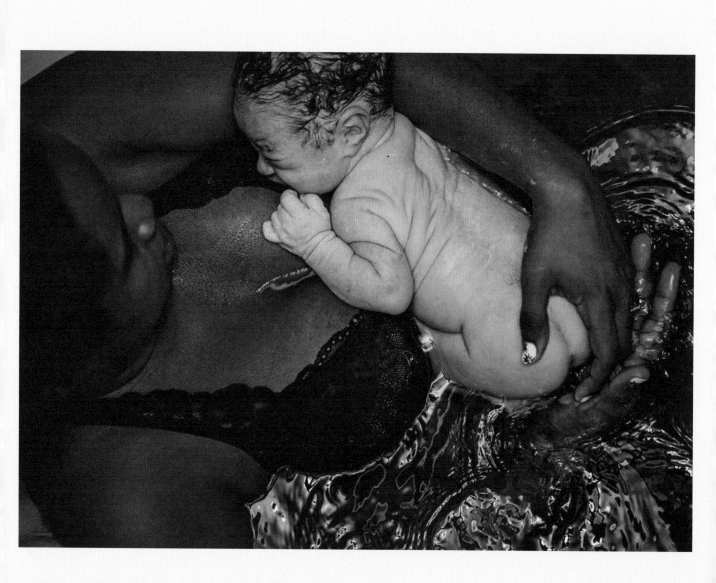

Cheznay Dones

It's a wonderful thought knowing you just birthed a tiny human.

Amy
Schumer

Ok here's my takeaway from pregnancy. Women are the shit. Men are cool and whatever but women are fucking warriors and capable of anything. I was lucky enough to get to have a doula. Her name is Domino Kirke-Badgley. What do doulas do? I don't totally know. But what she did was make me and Chris feel totally secure and supported throughout my pregnancy and the birth process.

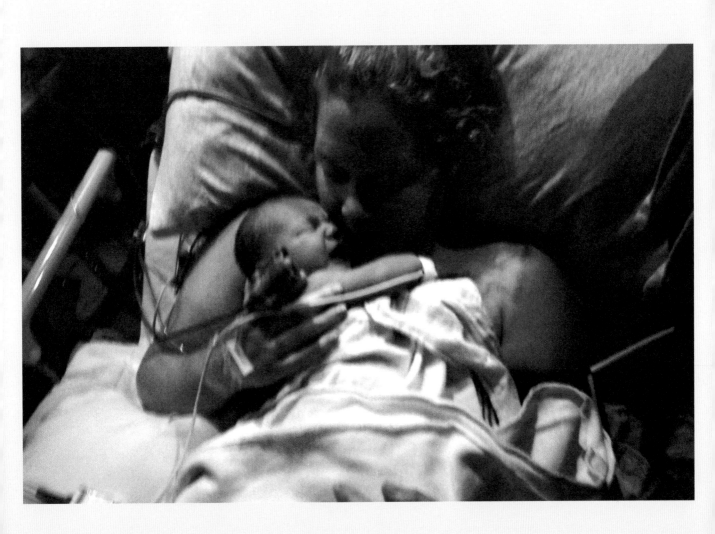

Anita Hickey

I had a difficult pregnancy, in which stillbirth was a possible outcome. Declan was delivered a month early and before I even saw him, the NICU team had him to give him oxygen. Holding him for the first time, I cannot express the emotions I felt when I felt his body rise and fall with each breath. My mom was there the whole time and, in that moment, I felt the power of motherhood, life bringing life, the wisdom across generations, and 100% pure love.

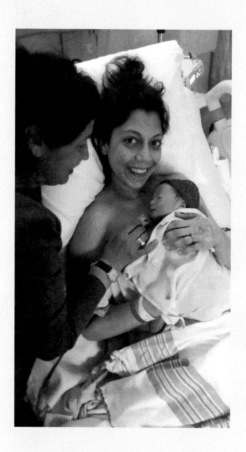

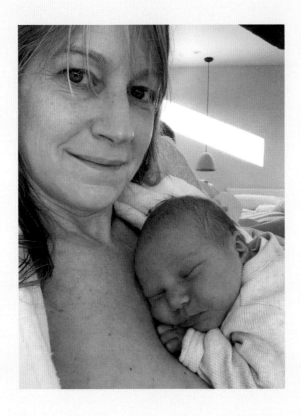

Looking at this picture after
I took it I realized how yellowish
and pale my skin was compared
to hers, and that I looked how
I felt: as if all of my life blood
had drained from me into this
beautiful new little creature
who needed it so, and that
was just fine. She could have
every last thing I had to give,
now and forever.

Jenny Bird

Ashley Graham

I was fortunate enough to be able to give birth at our home in Brooklyn, supported by my husband and an incredible team of women—my two midwives, Kimm and Kateryn, and my doula, Latham.

I had the hardest time focusing on what I needed to do to push through the pain and in this moment, Kimm was counting me through my contractions so I knew the progress we were making. The experience was truly transformative; it made me realize and understand the innate power of women everywhere.

Every day when I look at my son, Isaac, I am reminded of the strength of my body—all it has done and what it continues to do for me, something that I find incredibly empowering even now as I face challenges as a new mom.

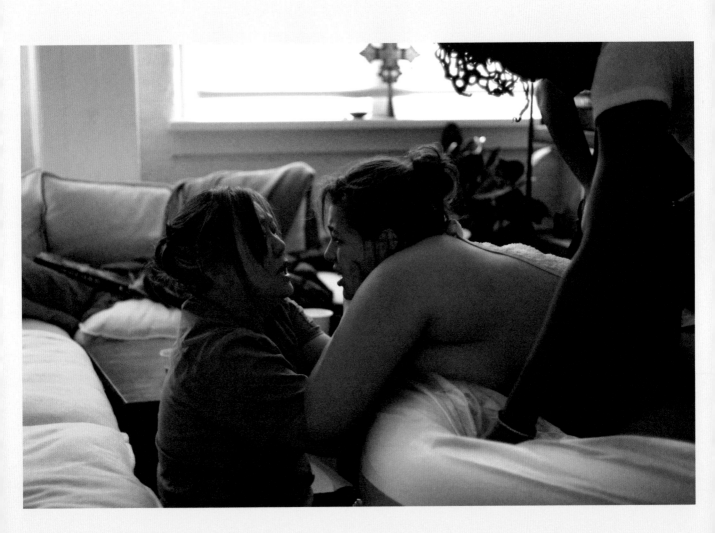

Brittany Young

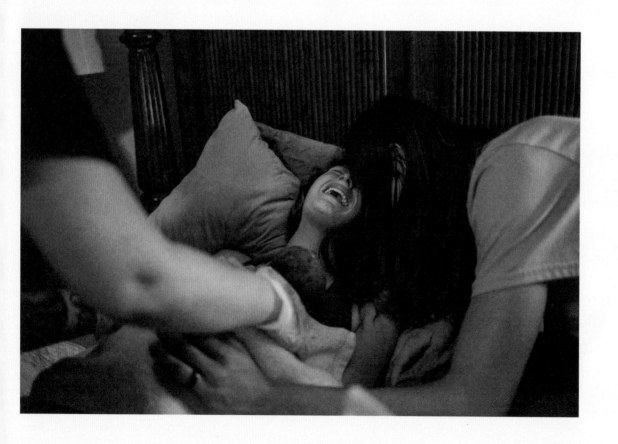

Esther Ruth Young was born at 8:17 p.m. after 13 total hours of labor. I was assisted by my husband, doula, and team of two midwives. My body has not gone back to "normal" pre-pregnancy shape, but it is an extremely resilient vessel that now continues to grow my daughter through breastfeeding. This is what my body was made to do, so I will breastfeed freely and unapologetically! All births and all bodies that have brought new life onto this earth are beautiful.

Cherie J. Cohen

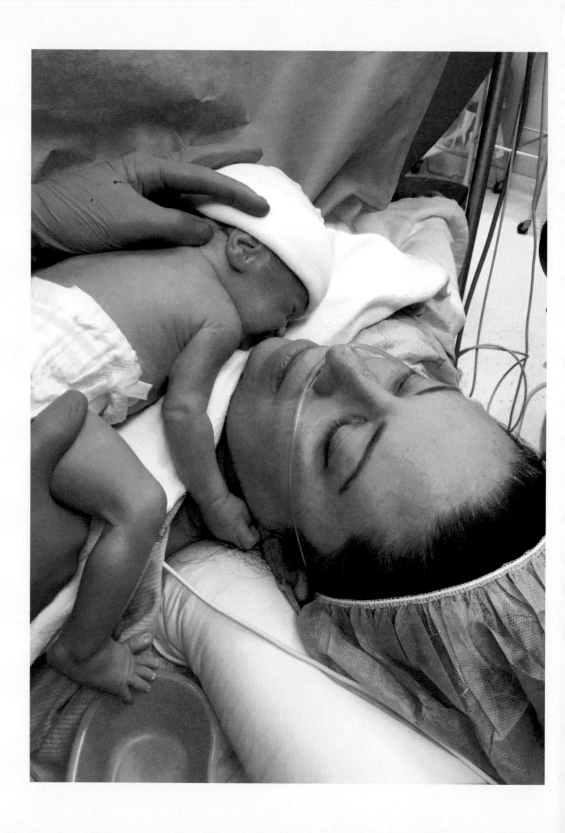

A Letter to My Newborn Son

Dear Coby,

Welcome to this big, beautiful world! I have waited for you, for a very long time.

You were part of my fifth pregnancy, yet it is you who have finally made me a Mama, as my first born. You are both my rainbow baby and my absolute miracle.

A very gracious egg donor helped create you. But I am and will forever be your Mama.

Losing your brother almost four weeks ago was horrific. Continuing to carry you both in my belly since then has been the most difficult thing I've ever done. But I can hardly imagine what this loss must be like for you.

As you get set to stay in the Neonatal Intensive Care Unit (NICU), please know I will always be here to love you, protect you fiercely, and guide you. My love for you was instantaneous and feels like none other I've ever felt.

Please don't leave me now. I need you to stay healthy, be strong, and continue to grow and flourish. I will be here with you, every step of the way, until we can both go home together. Now and forever.

I love you always.

Your Mama, *Cherie*

Christy Turlington

This is me pale but still smiling on day one at home as a new mom. Though I'd lost two liters of blood post delivery, I can't remember being more tired or more happy to have my baby girl in my arms after 42 weeks of pregnancy.

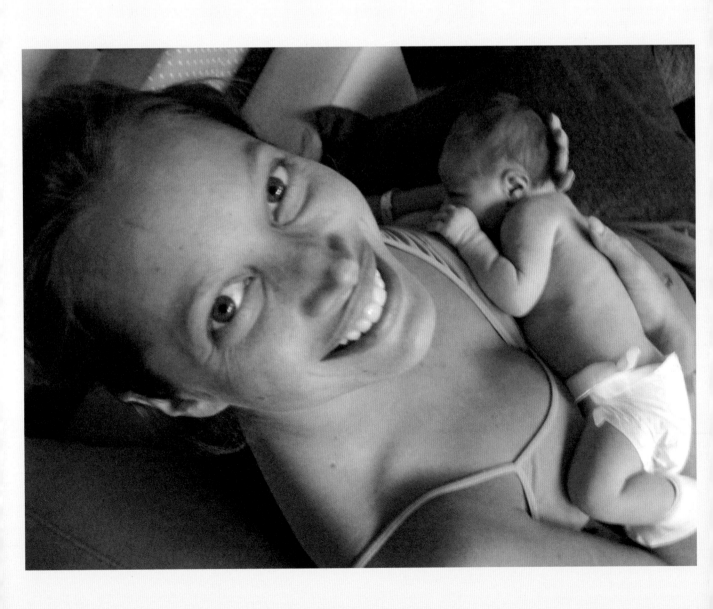

Ricki Lake

This moment when I pulled my baby out of my body in my bathtub was one of the most powerful and transcendent moments in my life. No words can fully describe that feeling of total empowerment and achievement and unconditional love. Love for my beautiful new baby, of course, but also self-love.

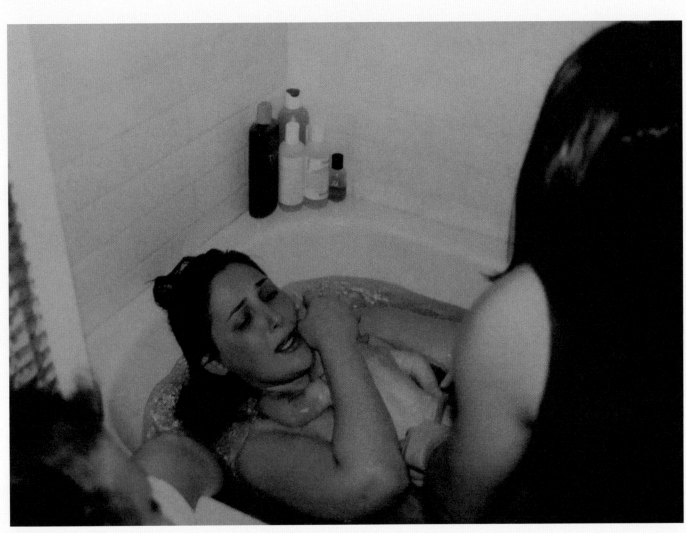

Gaia
Picciolini

Less than 24 hours
after birth. So empty,
yet so full.

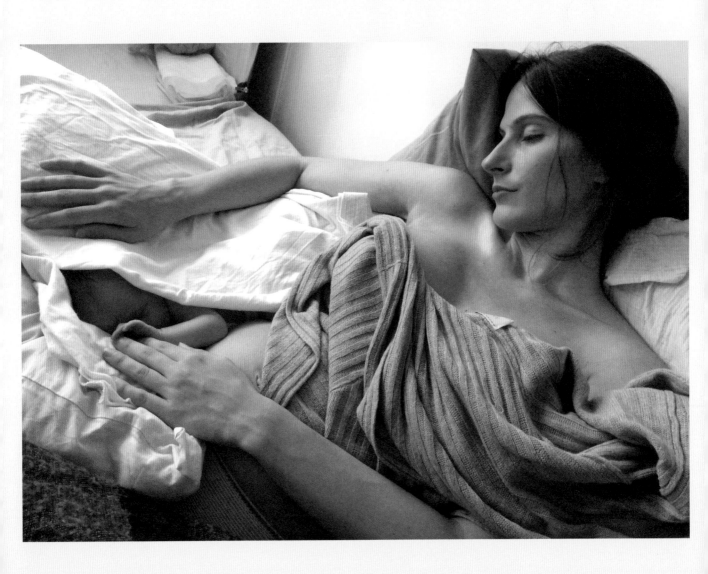

Heather
White

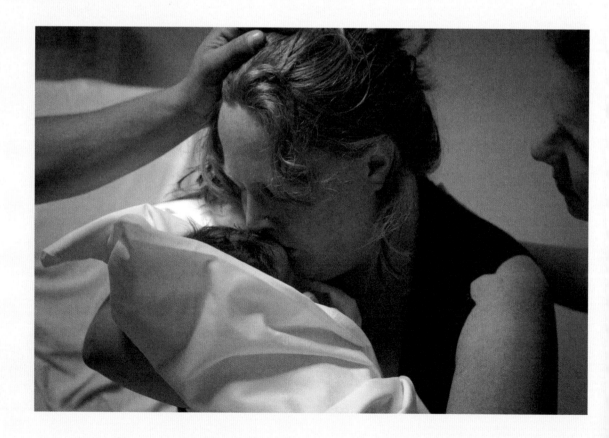

Through the devastating loss of my own child at birth, I was called to become a doula and birth photographer servicing others through their toughest moments in this powerful life transition. I am endlessly in awe of the power of birth and parenthood through the privilege of supporting and documenting almost 200 births. This is how I honor my son.

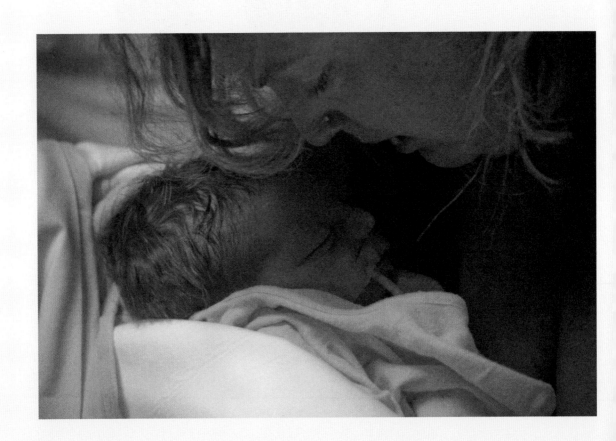

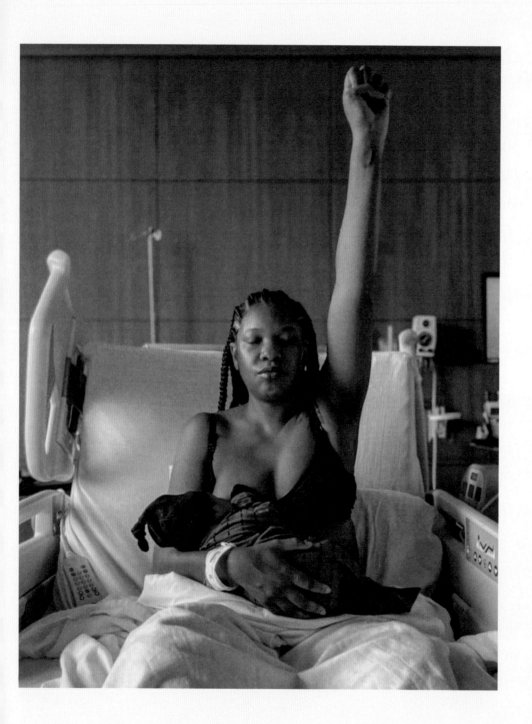

Jenny LeFlore

Strong as a MOTHER!

While the world was in chaos, I was focused on creating life.

Our son is here and we are blessed.

Libby King

He was born at 4:44 a.m. on October 28, 2014. Looking at this picture now almost five years later I see not just the beautiful human that had just been born but the family that was born, too. I think in our culture family equals togetherness and therefore an absence of loneliness. But in fact motherhood has been the loneliest time of my life. And why is this negative? Or why are we taught to expect the opposite? Clearly it's inherent somehow—part of our nature—and we are confronted with it daily once we become mothers.

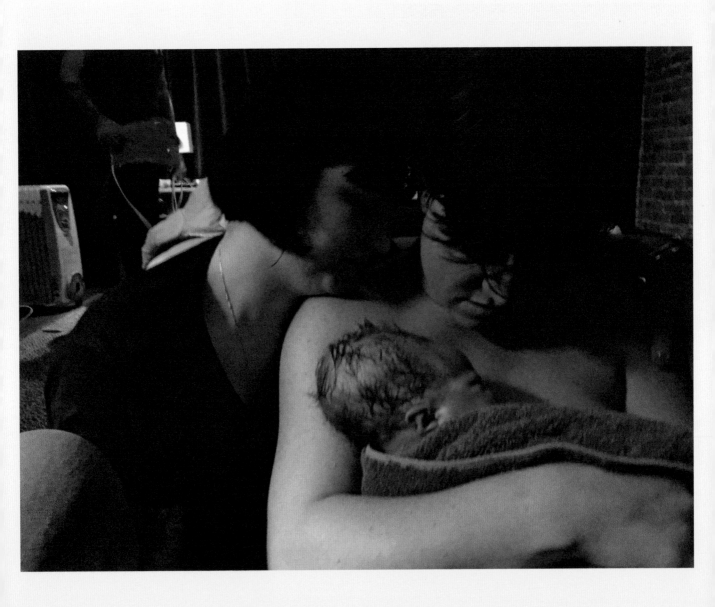

Rebecca
Ringquist

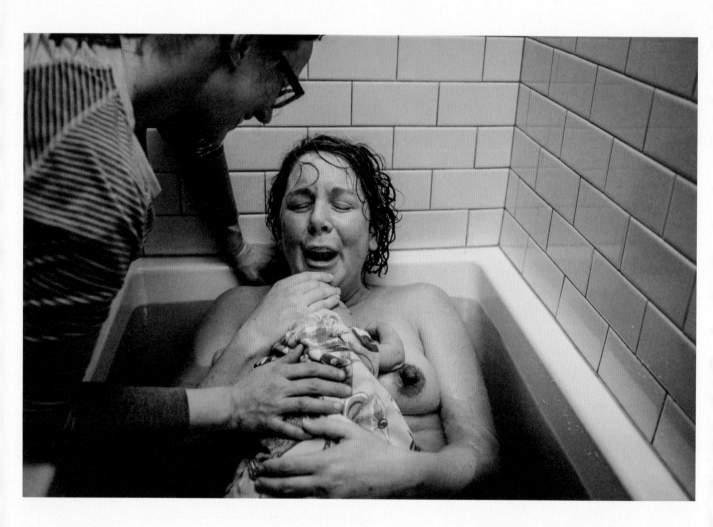

I walked into this birth while she was pushing. It was such a whirlwind. The midwives didn't even have time to set up the birth tub, so the six of us squeezed into this bathroom. In this moment, she is overcome with shock and relief over how quickly she gave birth. Her previous labor and delivery was much different and longer. Her partner was so proud and chuckling at her wife's adrenaline-filled ramblings about what she just did in their bathtub. All of it was so short and sweet.

—Kimberly Kimble

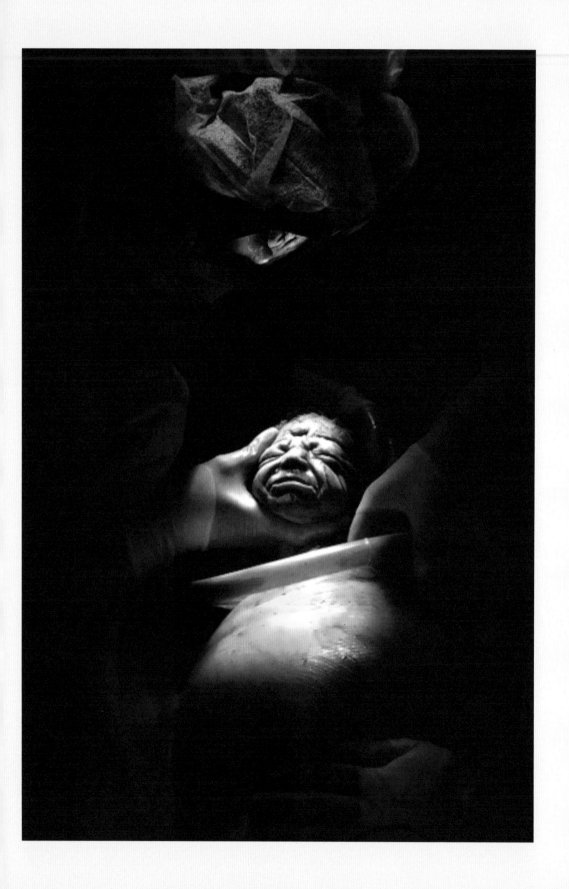

Lindsey Van Cleave

I did everything I thought necessary to have a natural unmedicated birth with my first child. I exercised, took hypno-birthing classes and read everything I could find about natural unmedicated births. At 3 a.m., six days before his due date, I woke up and the sheets were wet. My water had broken. Excited, I got up and started moving around to get labor started. Nothing. After seven hours, I called my doctor. Because my water had broken, they wanted to see me to assess any risk for infection. We packed up and headed to the hospital excited to meet our son. Forty hours later, after doing everything I could on my own, and not being successful I was told he was starting to appear in distress and needed to be delivered via C-section. Everything after that moment was a blur, but the second we heard his first cry and saw his sweet face, the way he came to us no longer mattered. He was healthy, safe, and our lives forever changed. We're all warriors, no matter how we bring our babies into this world. My incredible husband captured his entrance into this world beautifully in this photo.

Natalie Telfer

Your kids won't remember
much about the day to day,
but they will remember
how you made them feel.

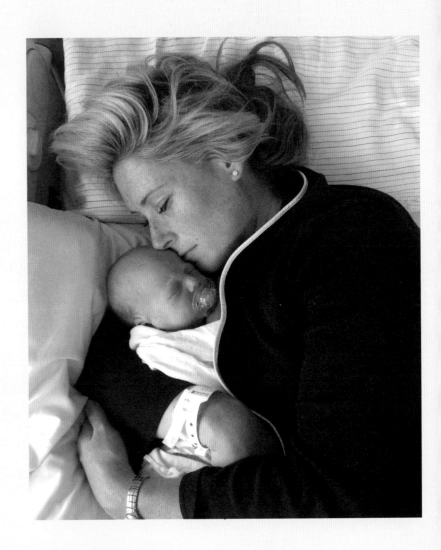

Nettie
Lile

This is Gideon, my son, floating in the tub, which is really this in-between space that we both occupy. We are still waiting for the placenta so we are still tethered together, still connected, but more separate than ever before. One body got into that tub and two will now emerge. We are gazing at each other for the first time and it feels cosmic—I sneak glimpses at his body but keep returning to stare into his eyes. Pure magic!

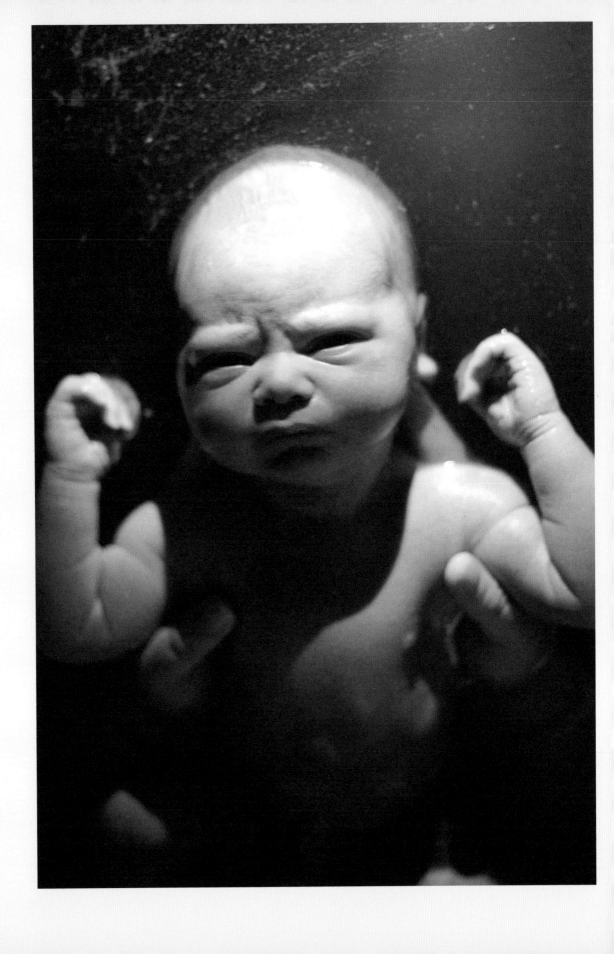

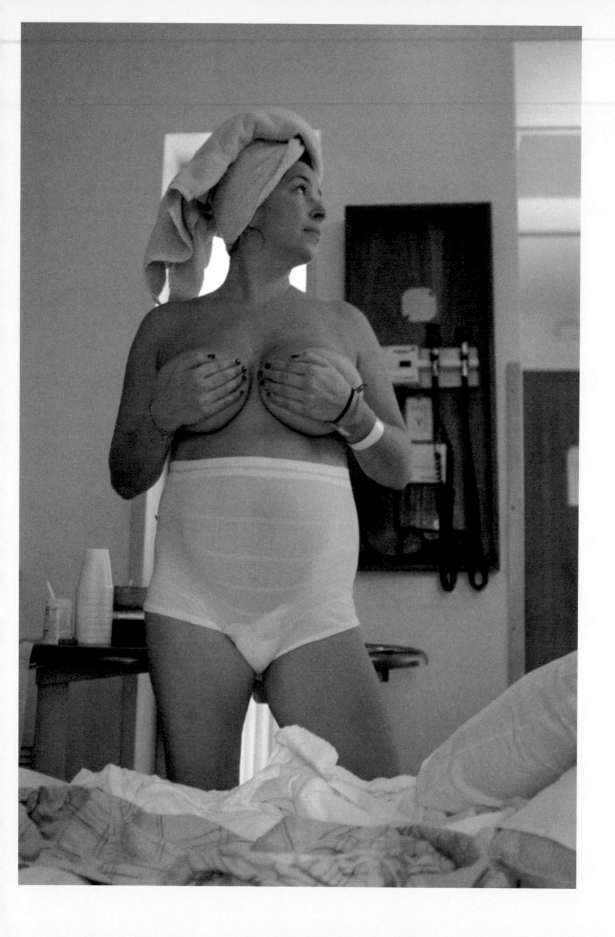

Rebecca Minkoff

This is a moment a few hours after I gave birth when I had never felt so proud, powerful, and giddy with the dose of oxytocin and overwhelming love coursing through my veins. I said to my husband, "take a picture so I can remind myself later about this moment, this magical feeling of having met another love of my life and feeling strong having birthed according to my demands and not those around me." I hated being pregnant but I thrive postpartum and think women are incredible beings who have more strength, resilience, and power than they often think. And yes, I stole this underwear and still have a pack unopened as a token of a time that goes so quickly and that I wish could be bottled.

Rocky Barnes

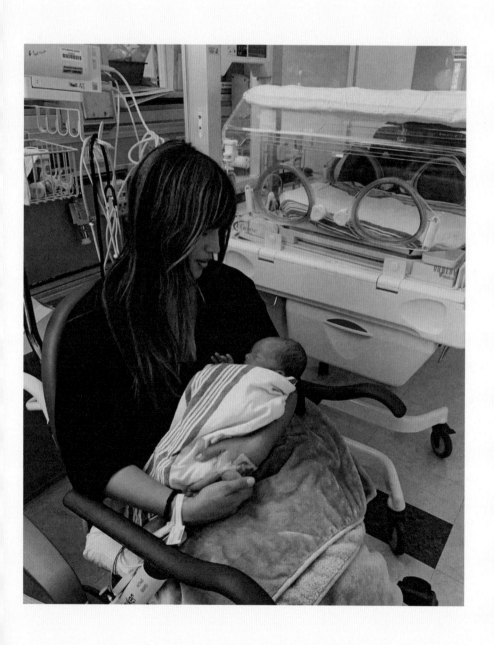

I'm not gonna lie, my pregnancy was a breeze. No morning sickness, no puffy feet, I felt great, it was business as usual.

Postpartum has been a different story. What was expected to be an easy delivery turned out to be traumatic for both me and Jones. Even with a natural birth with no tools, Jones suffered a subgeleal hematoma, multiple brain hemorrhages, and jaundice. I suffered third-degree tearing, quite a bit of time in a wheelchair and what is expected to be a two month recovery. Then add the emotional rollercoaster on top. Postpartum has been a mix of the happiest moments of my life, as well as some of the lowest. Hormones raging, I find myself crying tears of joy just looking at my son, and the next moment I'm filled with anxiety as to how I will ever be able to go back to work and be a mom. This new role as a mother is both amazing and overwhelming at the same time. I know these first few months will be tough (sleepless nights, constant feeding, pumping, and second guessing everything we do), but I am constantly being reassured it will get easier. I am so thankful for my husband and for all my friends and family that have reached out to support us. I am also so grateful for all the messages from other moms, many I have never met, who have shared their experiences, love, and support. The mom club is so real and I am so happy to be part of such an amazing community. I'm not typically one to write emotional captions but I'm pretty sure the hormones made me do it. Sending love and light to all the new mommas out there, we got this.

Shekiera Bright

The first moment when I held my baby girl. I can't even explain how all the pain I experienced over the last six years washed away in that moment. It was all for Dream. The miscarriage, the two ectopic pregnancies, losing both of my fallopian tubes, all the negative pregnancy tests, almost dying … and every single needle prick during IVF. Every emotion, every tear. My God is so amazing that he gave us this gift even when the odds weren't really in our favor. Everything in my life makes sense now. It all had to happen to lead us to Dream.

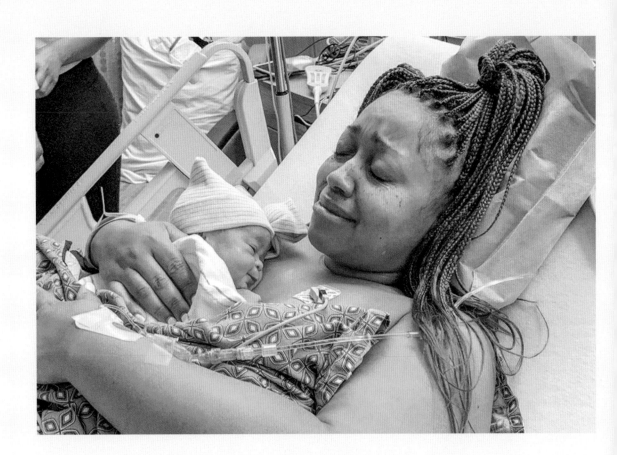

Stevie McKulsky

Our first latch.

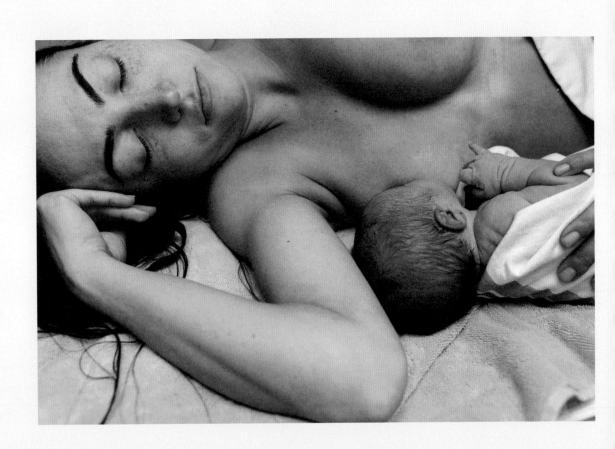

Violette
Serrat

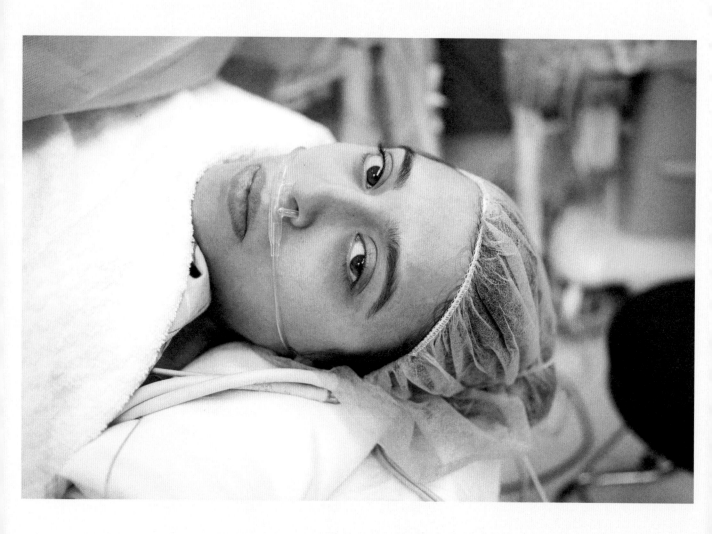

When I got pregnant I wanted to overcome the fear of giving birth, which had been passed on to me by my mother. It was deeply rooted inside of me.

However, I was determined to heal so I could have the best experience possible, for my daughter and for me. I tried everything, psychology, meditation, etc.—but it was when I read Ina May Gaskin that I healed my wound. The incredible stories and Ina's genuine angle, which does not embellish the stories but empowers you in adversity instead of making you feel victimized, were essential to reach a peace of mind.

So when the time came to be induced (I was 41 weeks pregnant and my baby didn't seem to drop at all), I went with my heart wide open and the faith that I could do it. I was hyper-empowered. I had decided to have a natural birth (no epidural) but unfortunately, after three days of very intense labor at the hospital, we had to go to the operating room for an emergency C-section. I was destitute: three days of fighting like a lioness

to finish with only this option. I was devastated. I was also terrified because I had never discussed the option of a C-section, so I had no idea what to expect. But the hardest part was knowing that I couldn't take my daughter in my arms as soon as she was born, which shattered me.

In this photo, I am scared, upset, dejected, but focused on the fact that I want to be there mentally for my daughter throughout the procedure. I am clenching my teeth because of all the drugs: my teeth are chattering and my whole body is seized. I'm trying to be still for the photo.

For several months I couldn't talk about my delivery. I couldn't even say that I "delivered." I had the feeling that my baby had been taken from my body.

I later found out that an emergency C-section after a long labor was much more intense on the body and traumatic on the mind. It gives me hope that for my second child (if one day we have one) I will be able to live through it more easily.

The birth of my daughter remains a miracle and this experience remains absolutely incredible.

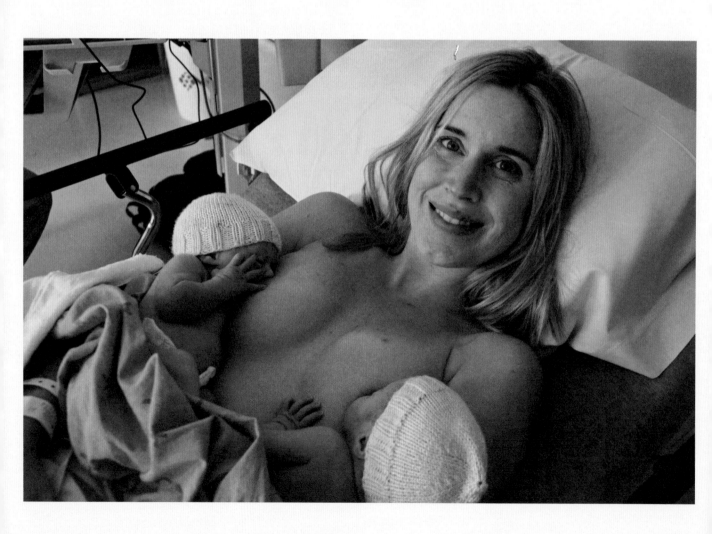

Meg MacPherson Morine

I don't remember much from this phase of life. It's all a mash of feedings and diapers and brief windows of sleep. I remember wishing to just get to the next phase. Always thinking how much easier it all must get. I suppose that is just a survival instinct that gets us through. But it doesn't get easier. It's just different. Each phase has a new challenge. The difference now is that I have stopped longing for what's next and I cling deeply to what is right in front of me—because if little babies teach you anything, it is how fleeting time is. I close my eyes now not to wish it away, but to imprint the memory of the moment so deep within me.

First Few Weeks

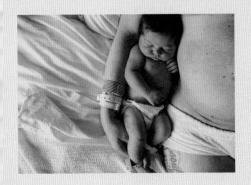

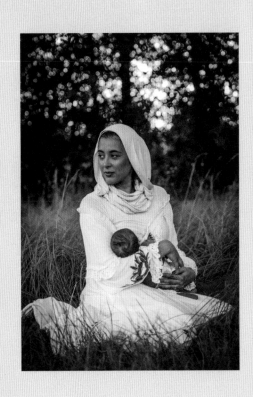

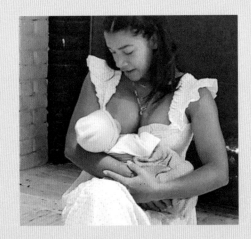

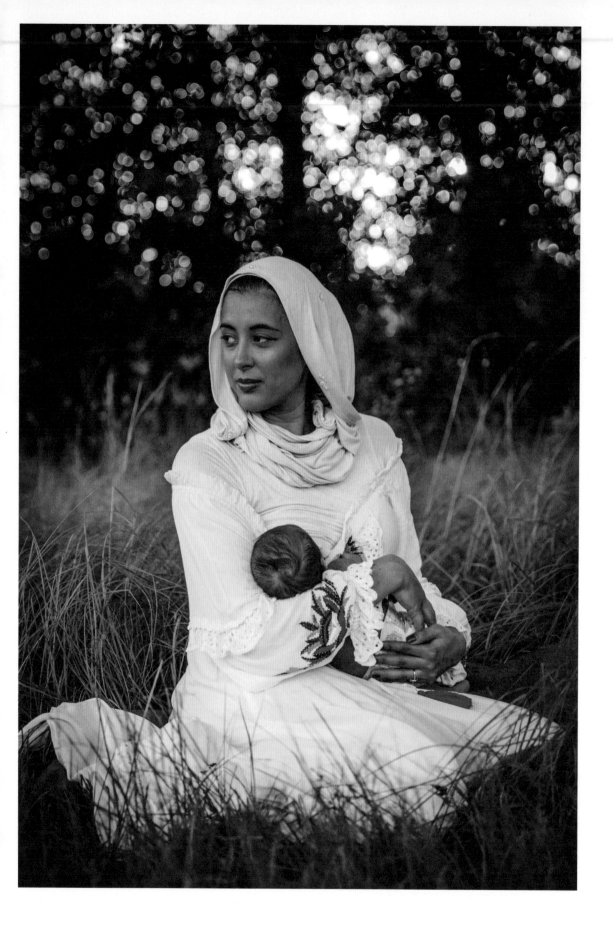

Adilah Yelton

Breastfeeding my third was not as easy as the first two. He was tongue tied, and it hurt to nurse him, with me almost cringing and dreading it every time. It took two weeks to work through it, lots of praying and hoping that he would gain the weight, and more importantly that it would stop hurting. This is the light at the end of our tunnel for me and my little man. Three weeks postpartum and things were working out for the both of us.

Alyssa
Garrison

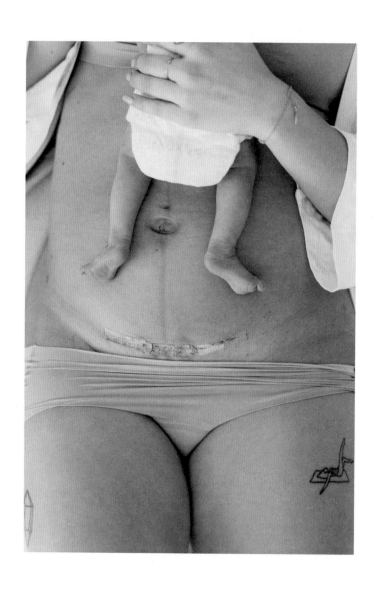

My birth was the opposite of everything I had hoped for. I visualized a calm, unmedicated home birth, surrounded only by my midwives, my doula, and all the women I love most.

The birthing pool was booked, the plastic sheets were ordered, and the breathing exercises mastered. I wasn't afraid to give birth at all—I was genuinely excited and fully ready to meet the challenge head on (vagina on?). A few weeks from my due date the midwives discovered my baby was upside down, or breech, and everything I had prepped for went out the window within moments. Hospital policy didn't allow attempts at vaginal breech births, though that's the way my mom gave birth to me, and staying home was considered very high risk. The midwives attempted to turn my baby with sheer force three times, but I ended up with a planned C-section—no laboring at home, or labor at all for

that matter. No doula by my side. No birth photographer in the room. Instead of breathing through contractions I was breathing through an epidural and waves of panic as I laid out on the operating table naked from the waist down in front of a room full of strangers. Going into birth without the adrenaline and hormones of active labor at work is the most surreal experience—you walk into the hospital on a totally ordinary day and just … have a baby within a couple hours. The moment I met my daughter was magical, and I'm so grateful for the positive C-section experience I had, but I still find myself waiting to go into labor, even years later.

Ariel Kaye

January 19, 2019. This is Lou and me five days
postpartum. It rained for the first two weeks
after Lou was born. We spent these precious days
skin-to-skin; warm, cozy, and resting in bed.

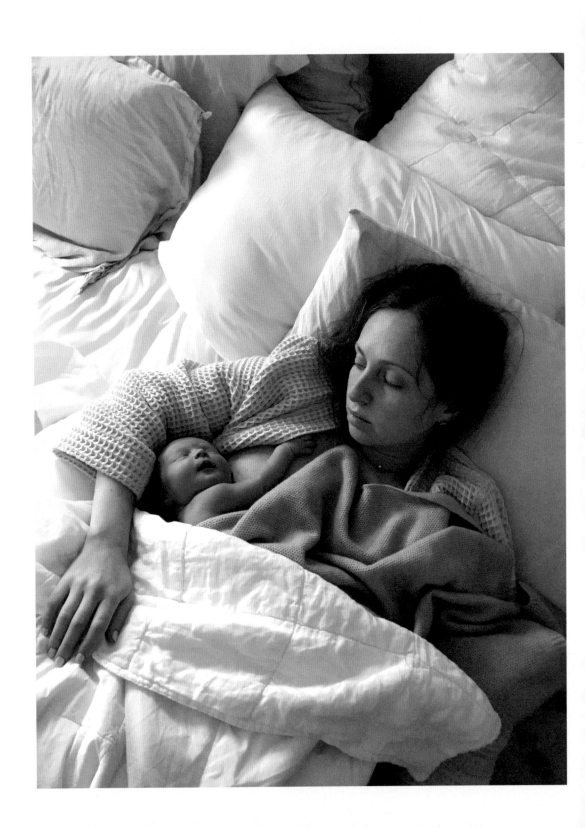

"For you created my inmost being; you knit me together in my mother's womb."
Psalm 139:13

Kara
Kasser

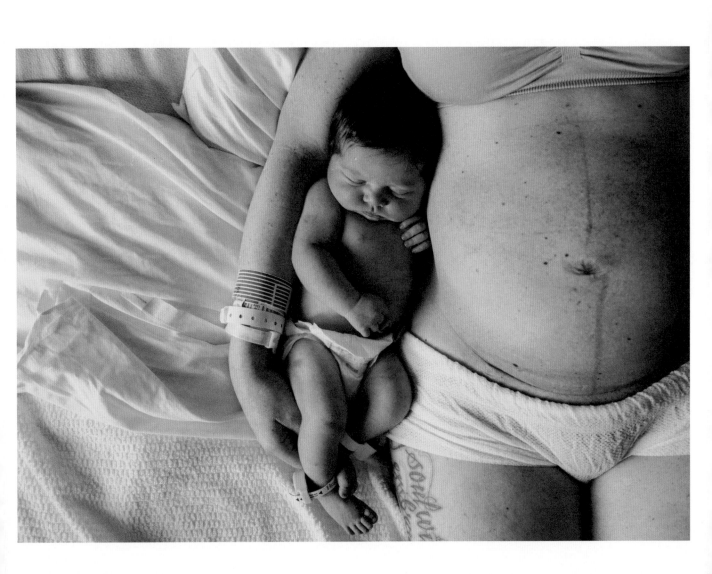

Elizabeth
Flynn

Love. It's simple, but also everything, more than words can describe, the whole universe in one moment, forever captured in time. The first bath for a baby, the millionth bath for a woman, born again as a mother, holding her daughter, Earth. Or is her daughter holding her? Tiny feet, milky breasts, that have somehow learned to nurture, to nourish this life. When this babe was born into water, existence shifted and suddenly everything had meaning. Water. Earth. Air. Fire. Stardust. This is what happens when there's a tribe. Midwife. Doula. Mother's Mother. Supported and whole. There's still more to this image than can be described. Sleepless nights, fearful pregnancy, tears, a right of passage that required some deep navigation—but here we are. Two women, on this planet, doing it. I never would have thought this was me, a mother, but this baby made me, and now I am.

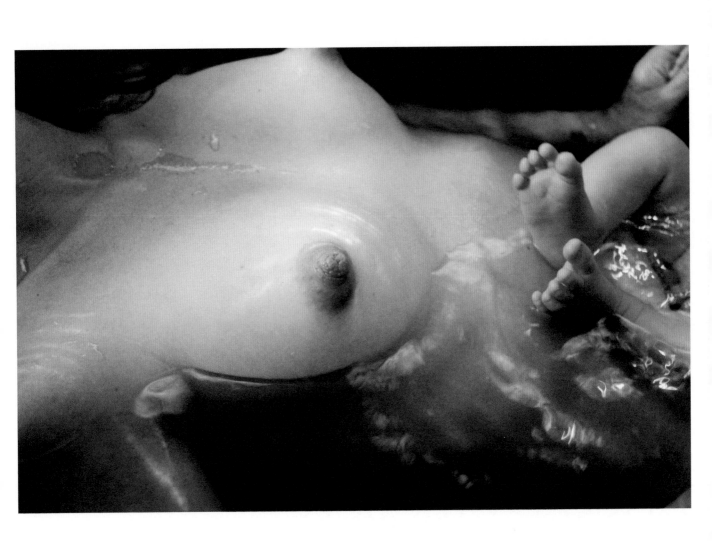

Navigating motherhood in the early days was rough.
I wasn't feeling mentally and emotionally all there.
My body still did not feel like it was mine. The kitchen
was my refuge when I found small windows of time
to whip up an omelette or banana bread. The nights
I made a full dinner were the ultimate win.

The kitchen has always been a true source of joy for me.
When I was cooking I felt like the old me, not the one who
was tethered to this newborn baby or my home.

I will never forget that this was a time I would be saying
goodbye to the old me, and starting to discover who this
new person was, the mother that I was now.

This was the ultimate DIY project.

Erica Domesek

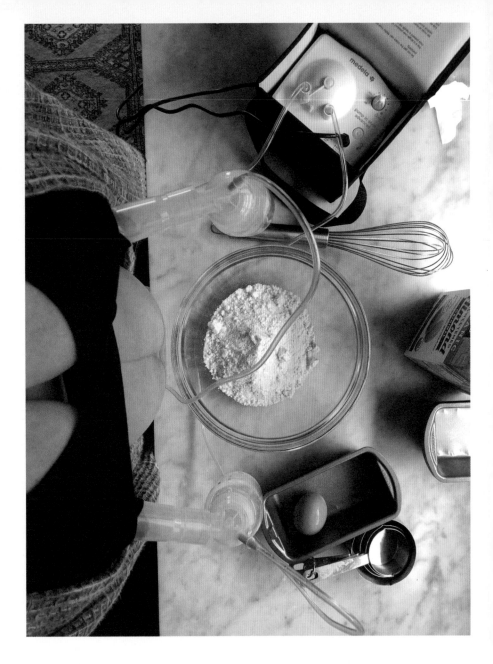

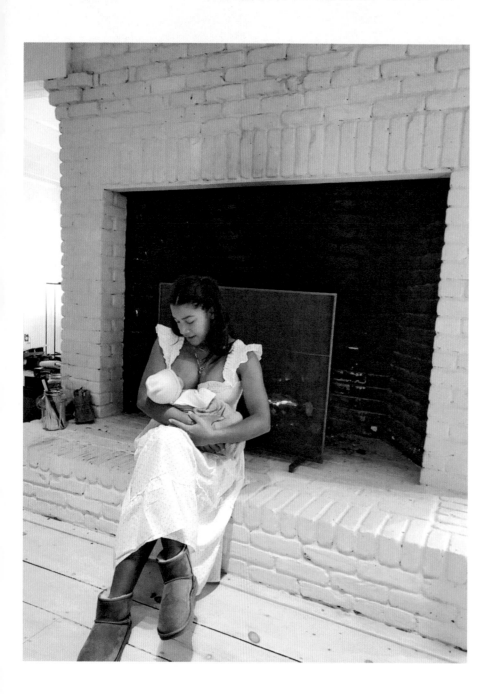

Living for these moments. The breastfeeding journey is real. I definitely don't have it figured out but one thing that is saving me is laughter! Every time I get spit up on, or spill my Haakaa full of milk, or have to spend 20 minutes blowing on his face to wake this sleepy boy up, I take a deep breath and let it roll off my back and let out a chuckle, because these are the moments I've been waiting so long for.

Hannah Bronfman

Erika Spring

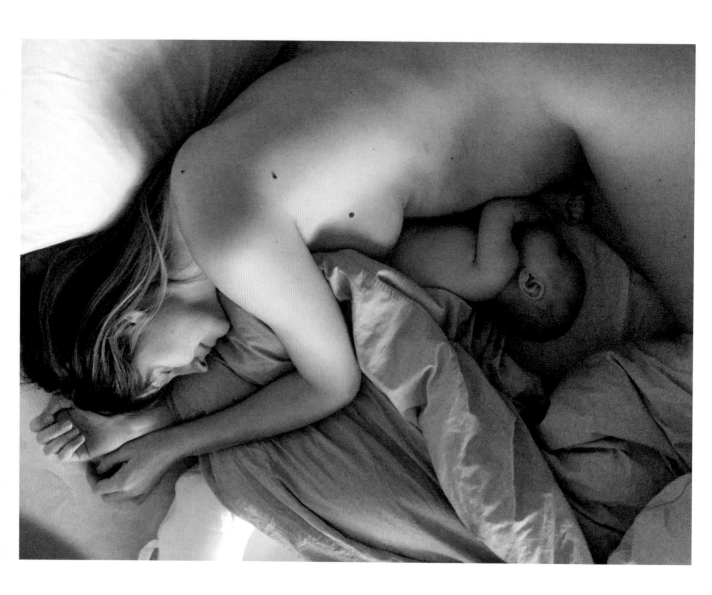

I'm almost three years postpartum. It's so emotional to see pictures and think about myself right after giving birth. I was so shocked at my birth experience that it took me a long time to come back into my body. I had internal scar tissue, which I didn't even know was a thing. The intimacy that I feel with my body now is something I treasure.

Jillian Harris

I look back at this picture and remember it being one of the best moments of my life. I've never felt so content with my body, my relationship with Justin, and my life. I think about how full my heart was that day. How hard I worked growing the baby, carrying the baby, and then delivering our sweet Leo. Luckily with that pregnancy and delivery, everything was perfect. Fast forward a few years and my pregnancy with Annie couldn't have been more different. I had debilitating exhaustion, feelings of depression, and a lack of interest in almost everything. I just wanted the pregnancy to be over. Luckily with both children I never experienced any postpartum depression or anxiety. However, motherhood can be a roller coaster of emotions. Every morning you wake up with a bursting feeling of love and appreciation and by 10 o'clock you're on a caffeine overdrive with nothing in your stomach and ready to run for the hills!

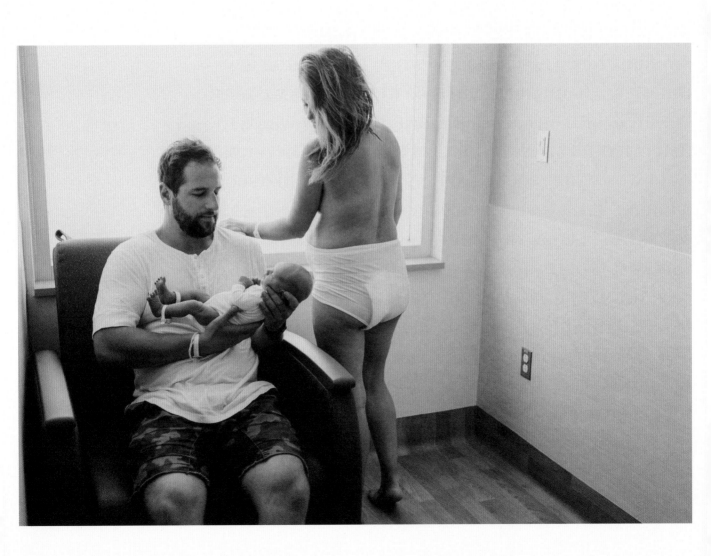

Joanna Griffiths

I took this photo during a hospital visit with a lactation consultant three days postpartum. She told me my breasts were the same size and just as hard as "soccer balls" and handed me two ice packs to help with the swelling. Elsewhere across town in those same few minutes, a team member stood in for me as we were honored with one of our biggest industry awards to date. Mentally it was a battle. I could build a company, but I was struggling to feed my child. I felt like such a failure. The nurse provided me with nipple shields, something I knew nothing about but saved me during that first month. In every image of breastfeeding I had seen the women looked natural, at peace and happy. I shared this photo and my sentiments on Instagram and was overwhelmed when over 100 people responded with their own struggles. In that instant, the idea for the Life After Birth Project was born. At that moment my eyes were opened.

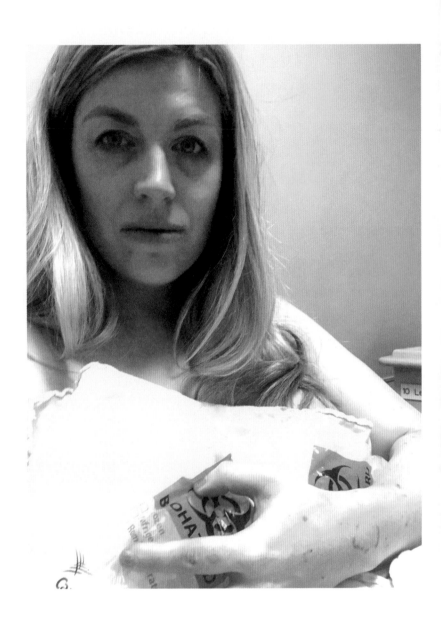

The healing connectivity of motherhood after birth should be protected at all costs. When we honor the mother, we honor her children. She is just as much newly born as her child. Protect the mother.

—Kirstie Perez

Teiah
Lucas

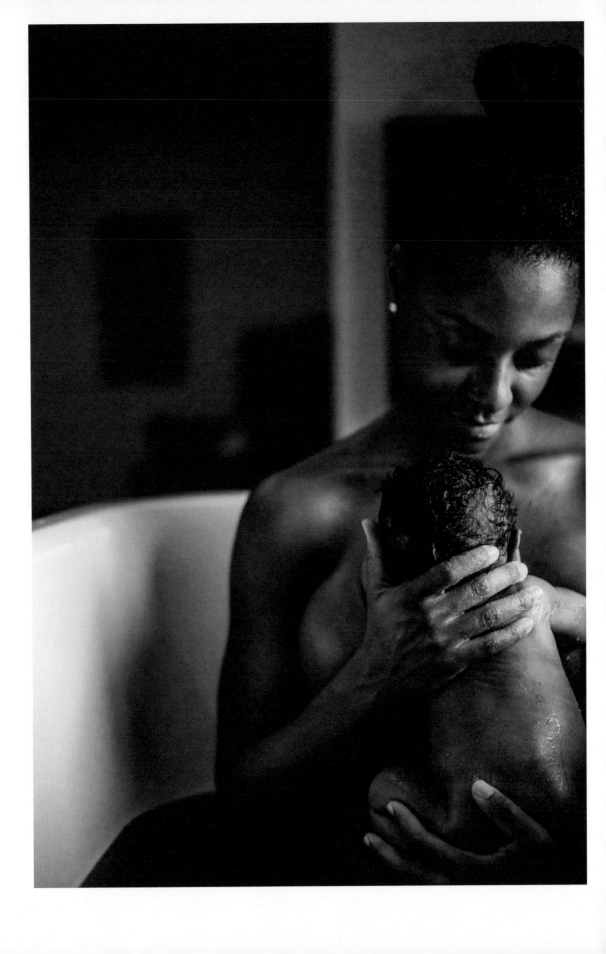

I knew as soon as we found out we were pregnant that I would have a home birth. There is something peaceful and protective about being in the comfort of your bed, bringing your baby into this world. She was born around the time that Trayvon Martin was killed. It was a bittersweet moment in my life, and I remember how safe I felt to be at home.

Mante Molepo

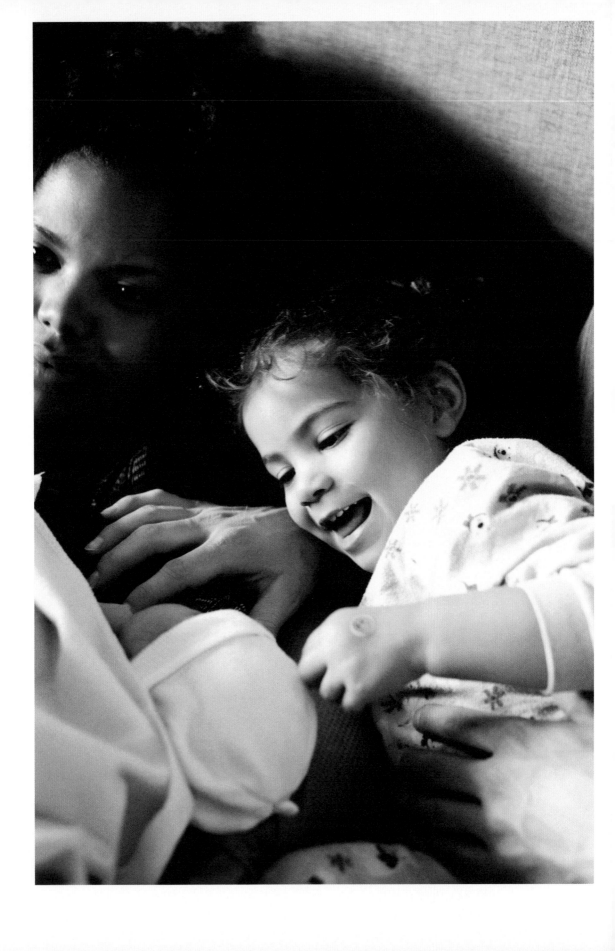

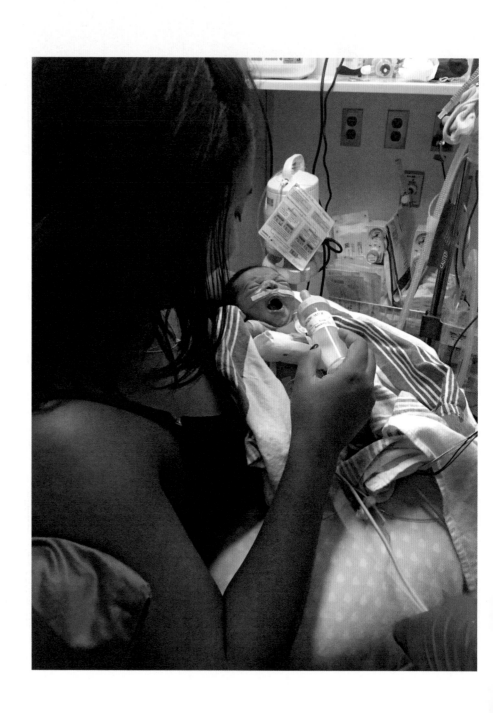

Melissa Duren Conner

The first time I was able to do skin to skin was three days after Reese was born in the NICU. Here I'm feeding her donor breast milk—it took a while to get my supply in because of the lack of contact, so I'm beyond grateful donor milk was available while I was struggling to exclusively pump and get my supply up for my daughter. It eventually happened and I fed her my milk via bottle until she was six months. We weren't able to establish a latch but I'm proud of what I could do.

When we were told the due date for our baby Eloise was in March 2020 the fun big debate was if she was going to be a Pisces like my husband or an Aries. Little did we know the stars were aligned in a different way and on March 27th, 2020, the world would be on lockdown due to Covid-19, leaving the labor and delivery to be isolated from family and friends, but also isolating coming home from the hospital. It's been bittersweet not being able to share newborn cuddles with our family or have a supporting hand physically and mentally during such an emotional time.

We are very fortunate to have a porch where we can hold Eloise up like Simba from *The Lion King* proudly meeting her family and close friends. To be honest, it might make it harder to see their adoring eyes through the glass and not be able to hug them ourselves. These "prison visits" are what we have to do at the moment, however, it's going to make a great story for her one day.

Pascale Hunt

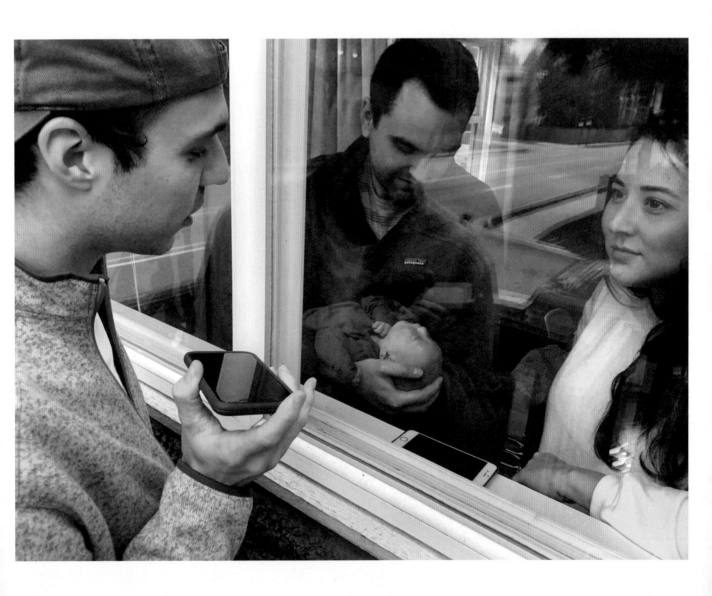

Everyone has a different bonding experience with a newborn, but I had expected it to be either the best thing in the world or postpartum depression. When I first met my baby boy, I mainly felt relieved and tired. I knew I loved him but the love didn't feel as overwhelming as I thought it should. For me, it came with time. The more cries I soothed, the more tears I shed, the more hugs we shared, the more the love grew.

Rebecca Huang

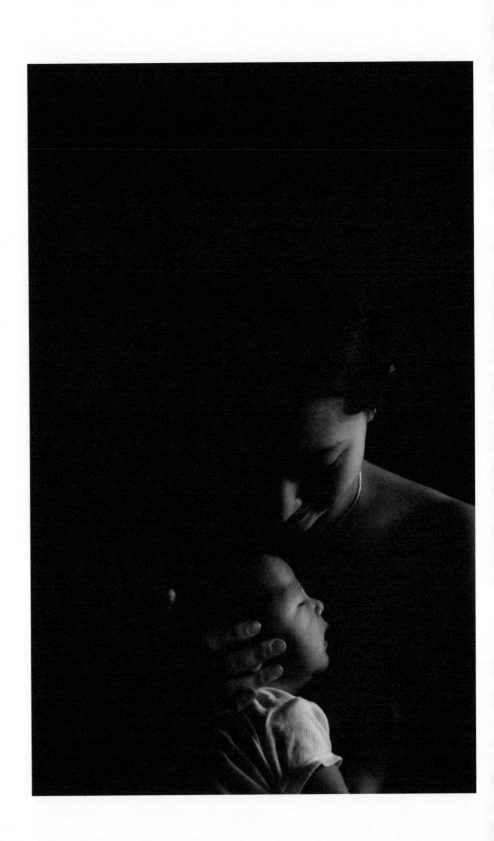

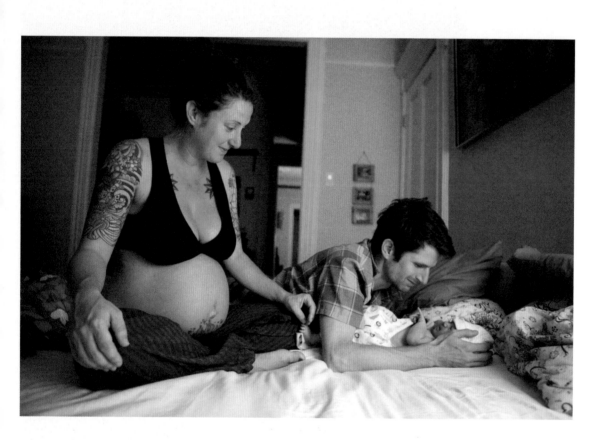

Samantha Huggins

The most profound rewiring of my brain, body, and soul occurred in the early minutes, hours, and days of the postpartum space.

Sazan Hendrix

Getting lost in the rabbit hole of weight and body comparison was something I struggled with in my first pregnancy.

I didn't understand what my body was doing, and that made trusting the process so hard for me. I spent a lot of days dwelling on the unknowns and I let anxiety rob the peace and the joy in my journey. I recognized something about my own mother that helped me heal in the process and I can't believe it took me until my third trimester of my first pregnancy to realize that never once when I was a little girl did I hear my mom say something negative about her body/appearance/self in front of me. Never did I see her pick herself apart in front of a mirror or even in a casual conversation with a friend. Little did I know, she knew I was watching. She told me that yes she totally had insecurities, but she decided when becoming a mom that she wasn't going to bully herself in front of her daughters. She decided she was going to be intentional with how she reacted to her greatest fears. I asked her: How? How did you manage to do this? She said, "I never gave negative talk the permission to speak lies over me." She also said, "It's amazing how your children can become the biggest inspiration behind why you choose to love and accept the way you are. If you can't do it for you, do it for them." Man, that really blessed me then and it blesses me now. As a mother to two sweet girls now, I've learned that just like the seasons change, so will you. Pregnant or not, right now is always a good time to be intentional with whatever life challenge you're facing and to choose grace over perfection. My mama said it best: "When you're unhappy with what you see, pretend there is a little girl watching who wants to be just like you. Don't let her down."

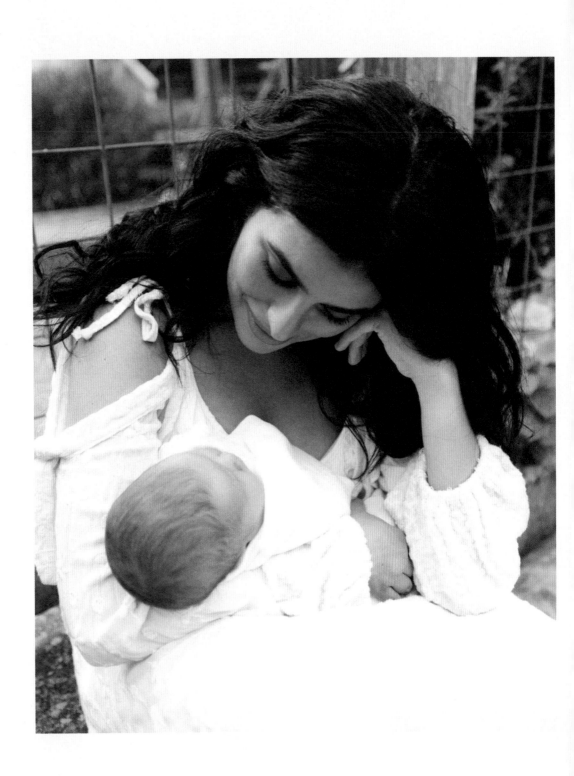

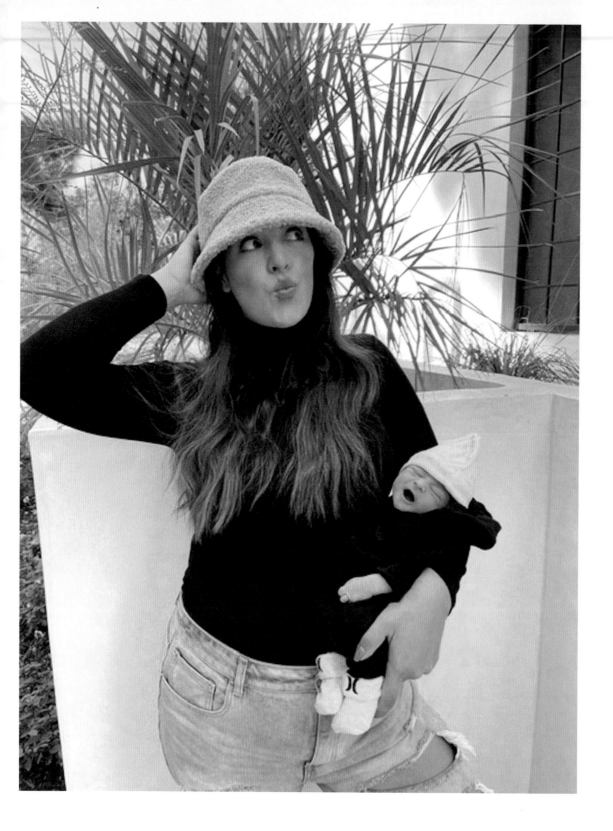

Can't believe our son was born a week ago! The instant love and obsession is so real. I find myself thinking about all the things we'll do together and simultaneously not wanting him to get any bigger, haha. I literally had no idea what to expect from motherhood but so far I love it so much! So happy to share this journey with you!

Kristina Zias

At one week postpartum, at 3 a.m., I woke my wife up and said something was very wrong. We called 911. When I first went in, the nurse thought that I had the baby blues when in fact I was terrified for my life. No one took me seriously. I had to advocate by myself at 4 a.m. and yell that I had just had a C-section to get a bed. Finally they took me seriously, and after tests, x-rays, and an echocardiogram, they discovered my lungs were filled with so much fluid and I had heart failure. I had postpartum preeclampsia, a very rare postpartum condition. I was admitted for three days—three days without my brand new baby. We couldn't bring her in because I was in the cardiac intensive unit and she was too new. No one told me the postpartum emotions were so raw. I was not prepared to be taken away. I was not prepared for my heart to fail. I was reunited on the evening of the third day and haven't taken a moment for granted ever since.

Sophia Dhrolia

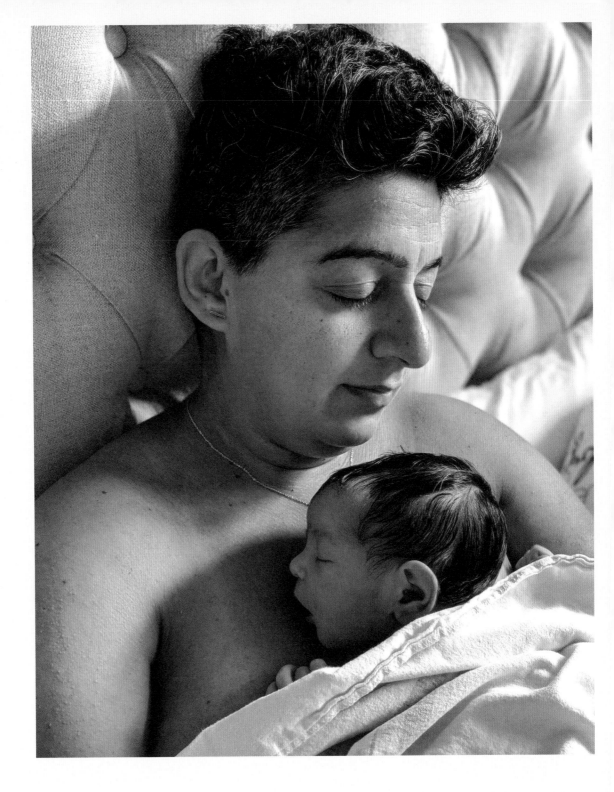

Yessenia Morales

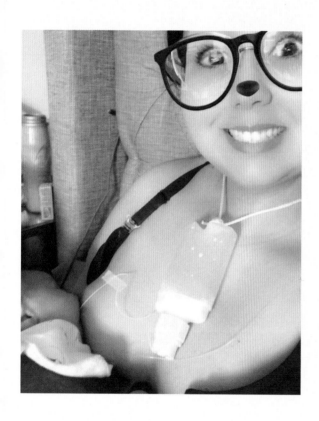

This is the hardest yet most rewarding experience. We had quite the journey, us two.

Breastfeeding was magical, like lots of women would describe it, but no one ever mentions the work, stress, commitment, and long hours it comes with—it is not easy. Maybe it comes easier for some women, but my journey was much different from how I thought it would be. I struggled with my milk production and at first I thought it was normal and thought I would eventually increase my supply. I nursed, I pumped, I manually expressed, I worked with a lactation consultant, I used two different breast pumps, I tried so many herbs and cookies available to help with lactation, I fed at my breast with a supplemental feeder. With everything in my soul, body, and mind, I tried. I wanted to give up so many times but I kept trying. Our bodies are truly amazing. We are given life, grow it, carry it, birth it, and some feed for days or months, or even years! Whether you nurse, pump, use donor milk or formula, feeding our little ones truly is a labor of love.

Vivian Kwan

Never did I think I would
become a mum! But here
I am. After 18 hours of labor
with 4.5 hours pushing,
the love of my life was born.
These early days have been
absolutely amazing and
exhausting. I am enjoying
every little moment with him
and I have officially become
an obsessed mum.

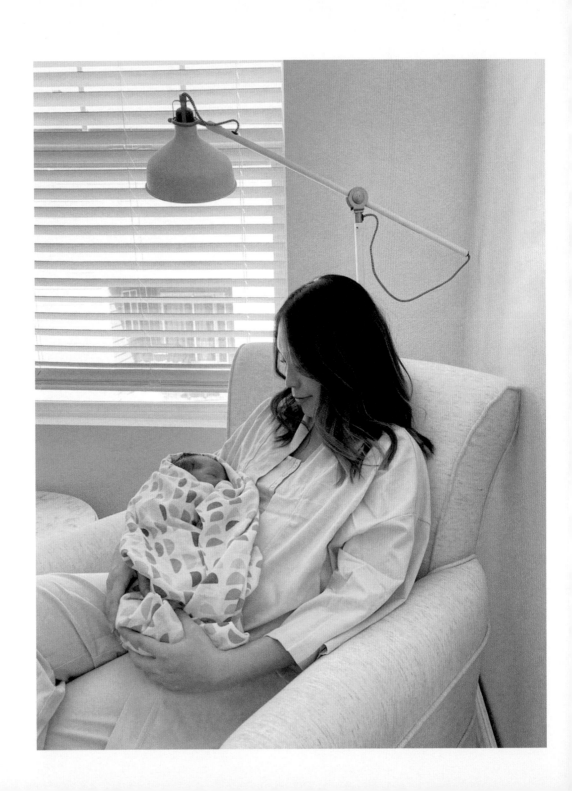

First Few Months

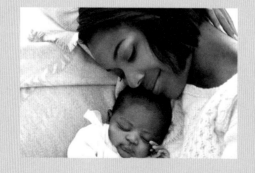

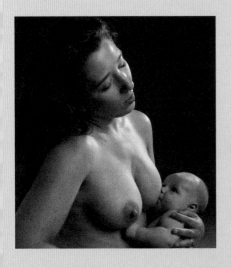

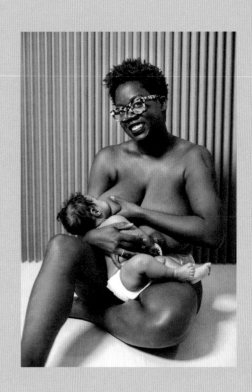

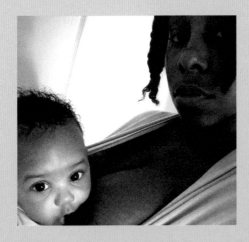

Abby Epstein

Although my first birth (an emergency C-section) was traumatic, I never felt that my baby and I were in any danger or that my birth team couldn't handle the situation. I surrendered to the birth my baby needed, and I never felt disappointed. When I became pregnant again, I chose to stick with the same practitioner, whom I trusted, and I was able to have a vaginal birth after cesarean (VBAC). I can't say that my VBAC was a transformative or healing experience for me—it was a difficult birth for me and my son. But immediately after the birth, I was empowered to realize that I was made of stronger and tougher stuff than I knew.

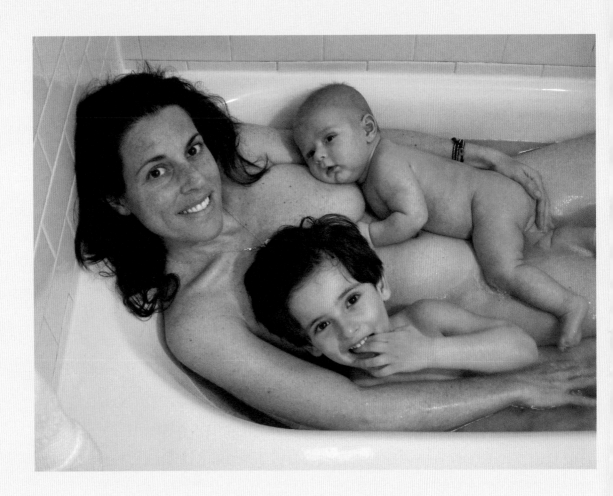

Amber van Moessner

At nine weeks postpartum, I felt equal parts amazed and betrayed by a body that had swollen, stretched, and sagged to make a baby. All I could focus on was how different it felt from my old body, my old life. I reached out to participate in the Life After Birth Project looking for a lifeline. I wish I could see then what I see so clearly now: motherhood is remarkably beautiful. I want to go back in time and tell myself to stop judging myself in the mirror, stop praying to fit in my jeans. My body grew, cared for, and fed the person I love most in this world. It protected me, it healed me. Motherhood forced me to slow down, to be present, to forgive my ancestral traumas. Some days I feel like a total badass ready to take on the world and juggle 100 things; other days I have no idea what I'm doing, feel totally incompetent, and question why I thought I was cut out for parenting. But every day I learn new things about myself and what I'm capable of. Motherhood is a high-wire act, a grounding, a gift.

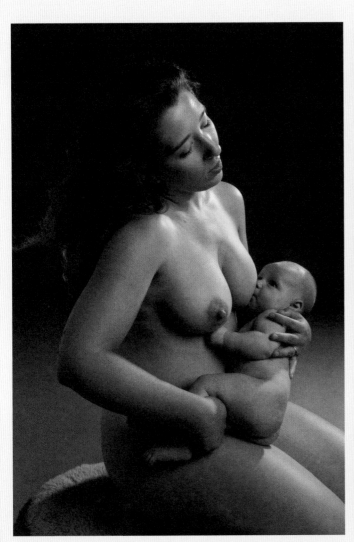
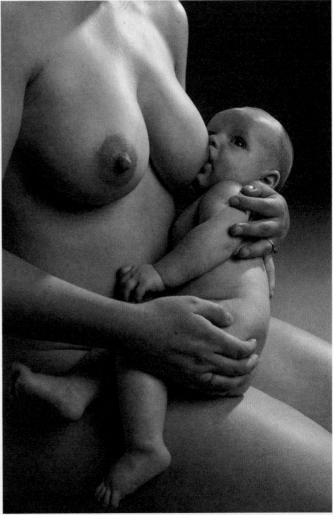

Cheska
Sia

Motherhood: stretch marks. Each stretch mark could be felt. Each stretch mark internalized. Each stretch mark represented the strengths and struggles of providing all the necessary resources for creating a new life. Stretch marks: motherhood.

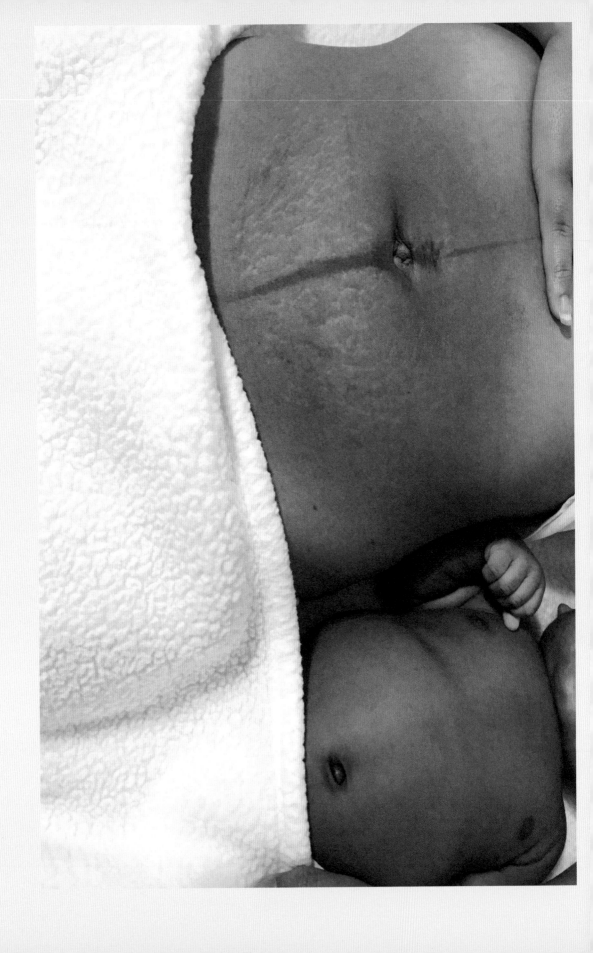

Behind that smile is years of trying and crying. Behind the smile is a community of women who I've relied on for support and advice.

I was so afraid of postpartum. In my mind, it was a word that had a negative connotation. Unfortunately, it was the only narrative I was hearing throughout my pregnancy. "Beware of postpartum," "it's an awful experience." But this journey, as difficult as it has been to get here, with all the failed IUIs and doing a cycle of IVF, postpartum has been a joyful experience. All of my worries and insecurities are still there and ever so present but right now, I'm taking things day by day.

Corrine
McPherson

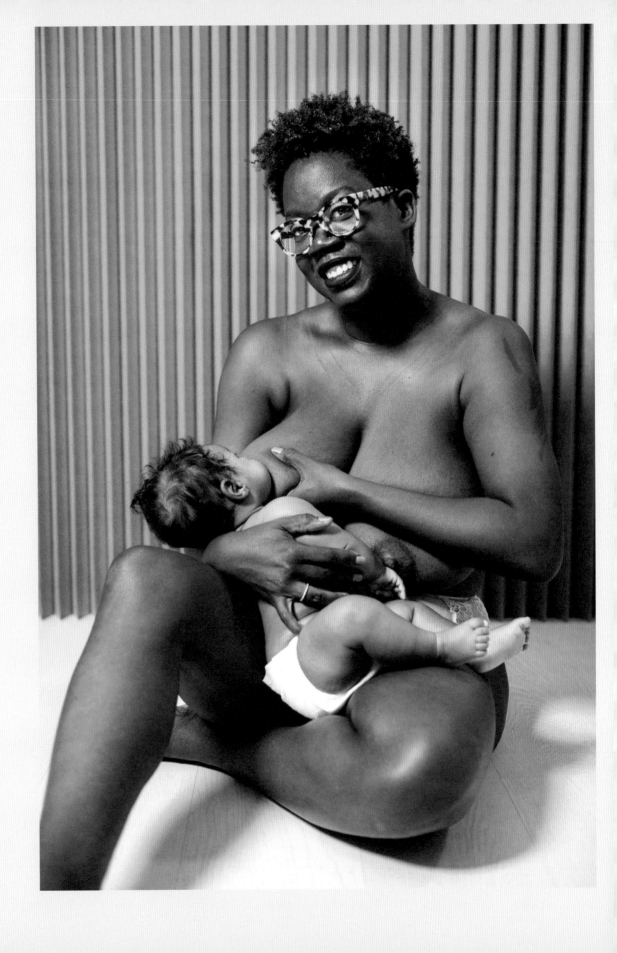

Elizabeth Flynn

Tenderness. Tiredness. Overwhelmed. The sudden realization I'd brought a baby into the world and I was no longer a girl, now a mother. The ground-shaking love I had for this little babe, but also the realization that life would never be the same. I was supported, nourished, but still off center. The night before, I took my baby outside to see the stars. The whole world opened up, I felt so big but also so small. It reminded me of birth, the oneness of it all.

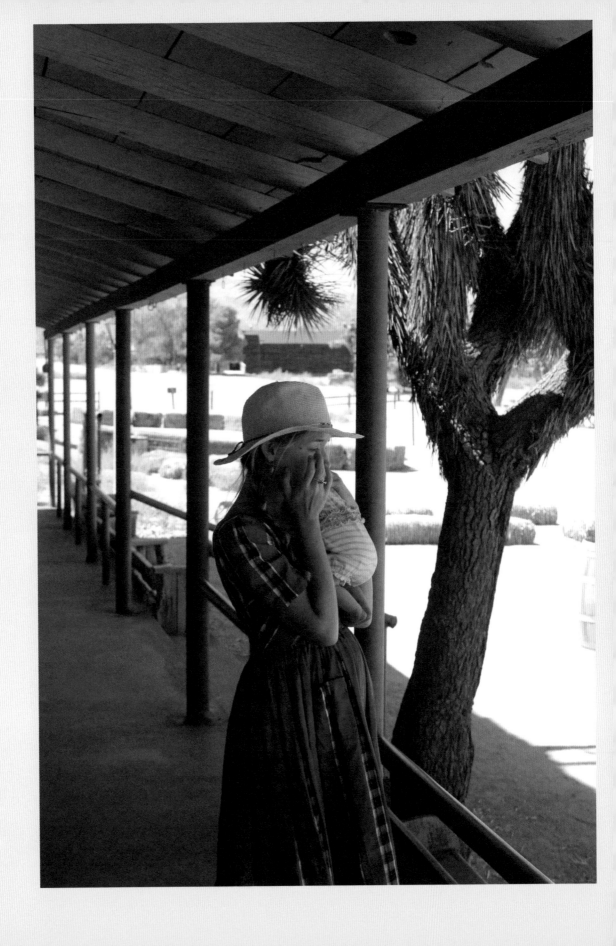

Gabriella Woodward

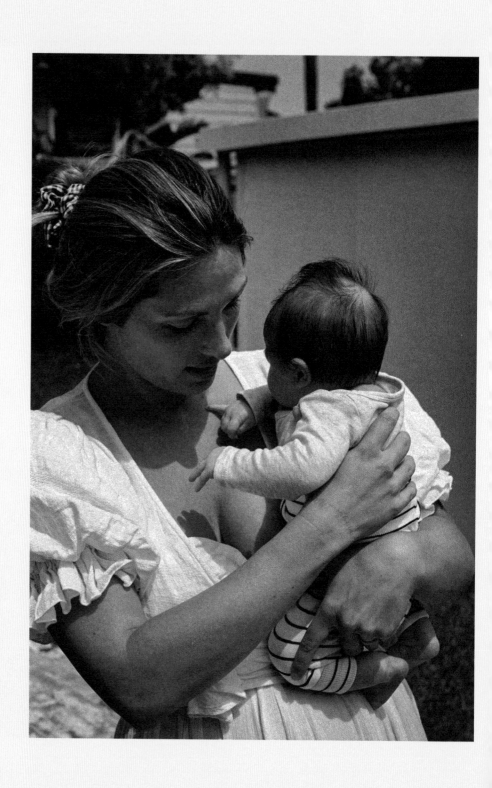

My postpartum journey was a very nurturing experience. With our second baby, Dash, I was fortunate to have our planned home birth. The oxytocin I experienced was immense and I'm still so grateful for the team I had around me.

Following the immeasurable care provided by my two midwives and doula, my husband took charge of our home so my body could heal. There are always unexpected struggles during the postpartum period, but I felt better prepared the second time around adjusting to the "new normal" of raising a toddler and caring for a newborn. We love the chaos.

The blessed gift that keeps on giving.
To everyone feeling alone, scared, unsafe,
unsure, without hope … hang on. Hang on.
You are loved and you are not alone. Been
there, hold on. Love and Light to all.

Gabrielle
Union Wade

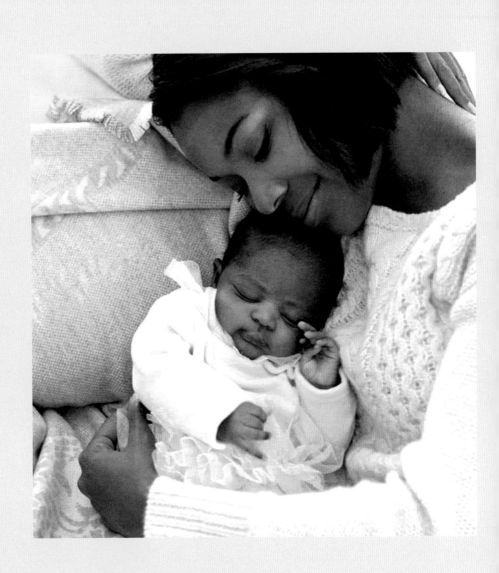

First day back to work and look who is my assistant director! Has a desk and everything!

Eva Longoria

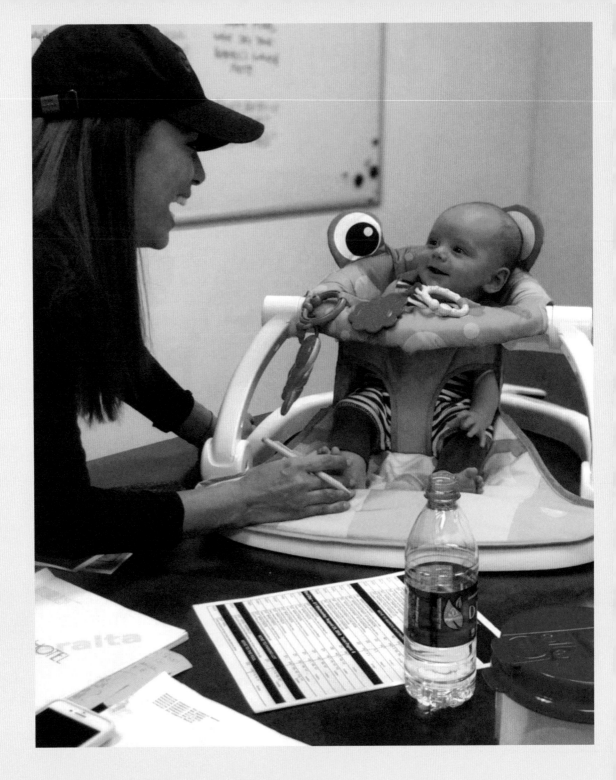

Kemi T. Akinyemi

This photo was the reality of postpartum. I was tired and in pain from the C-section. My son constantly wanted to be held, my hair was falling out, and I had just finished crying; it was my new normal life. The warmth of love is still there. I looked at him in my bathroom mirror and I realized the beauty of feeding my son made that moment of so many emotions feel obsolete; it made me feel centered. It reminded me I'm doing my best, so let God do the rest.

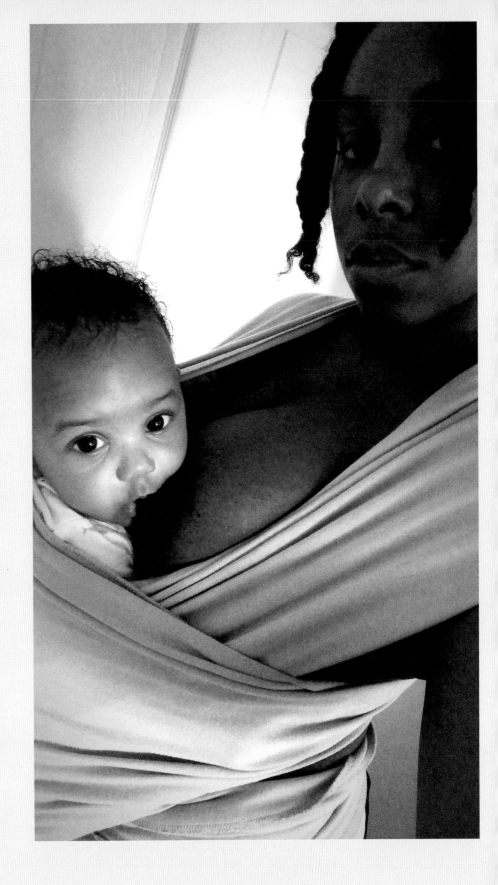

Mariana Azevedo de Oliveira

Three words to describe my labor? Breath, patience, and strength. I was shocked how strong I could be.

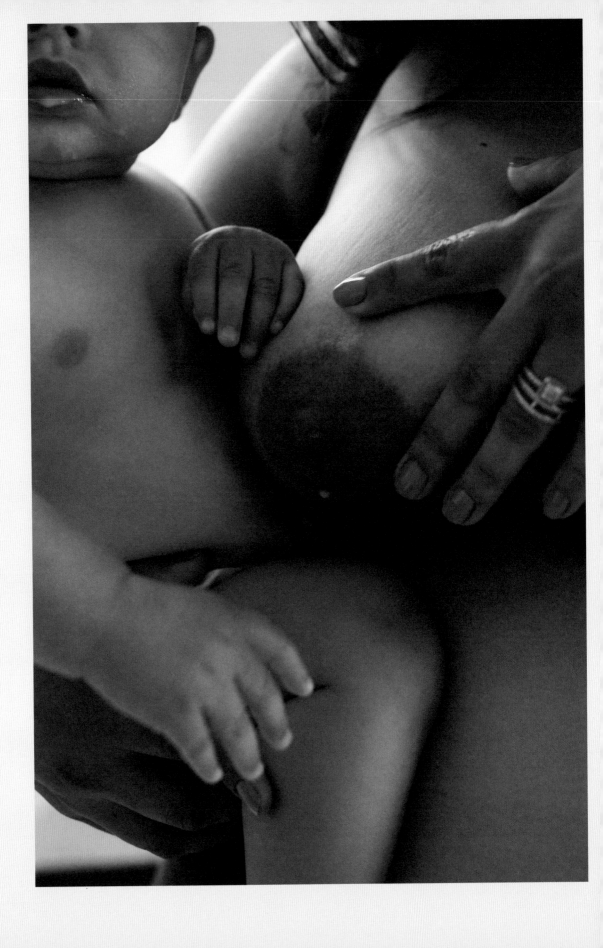

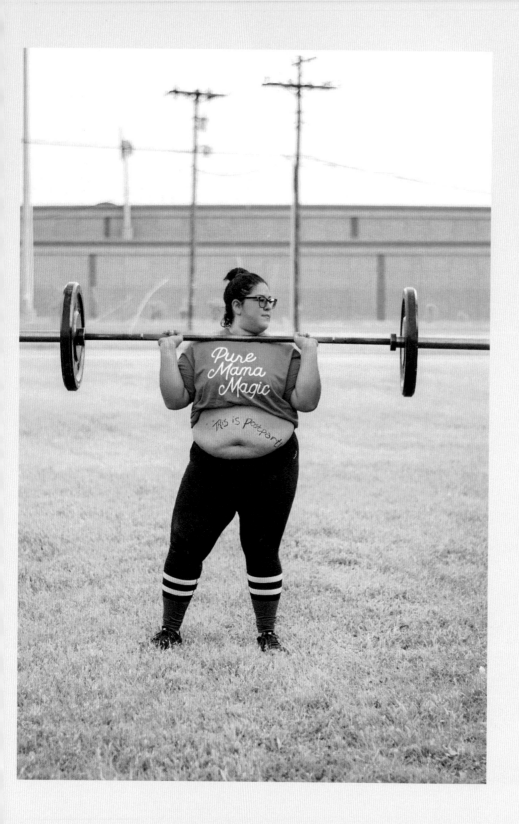

Meg Boggs

I was two months postpartum when
I first tried to lift some heavy weights.
And I haven't looked back since. When I
said fitness is for everybody, I meant it.

Mia
Matias

My husband took this photo because we had to go home in the middle of date night to pump because I was engorged. We were salsa dancing in 100°F weather (why I was naked). Every time I look at this photo it feels like a fusion of my two selves: the woman who feels sexy in a red lip out dancing in the city and the dedicated mother who needs to make a pit stop to pump.

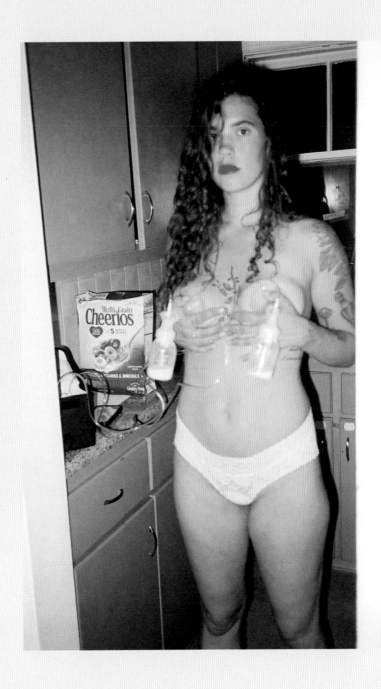

Tina Tyrell

The postpartum period with my second was bliss that lasted for months and months. I had a difficult pregnancy complicated by a painful proliferation of spider and varicose veins that seemed to get worse every day. Standing was very painful. I just had to sit idly by while my leg, previously my most attractive physical attribute, became something out of a horror movie. Every day uglier and uglier and more and more painful. By the time labor came, five days early, I could not have been more ready. I needed to get my body back so that I could start to heal it. Immediately the leg improved and I was able to focus on my sweet daughter who I had wanted for years to make my life whole. Our family felt balanced in a new way.

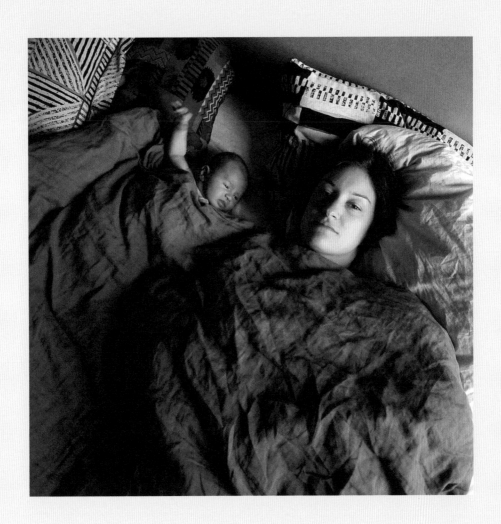

Tracey Cooke

It gets better. It gets easier.
And you'll be stronger for it.

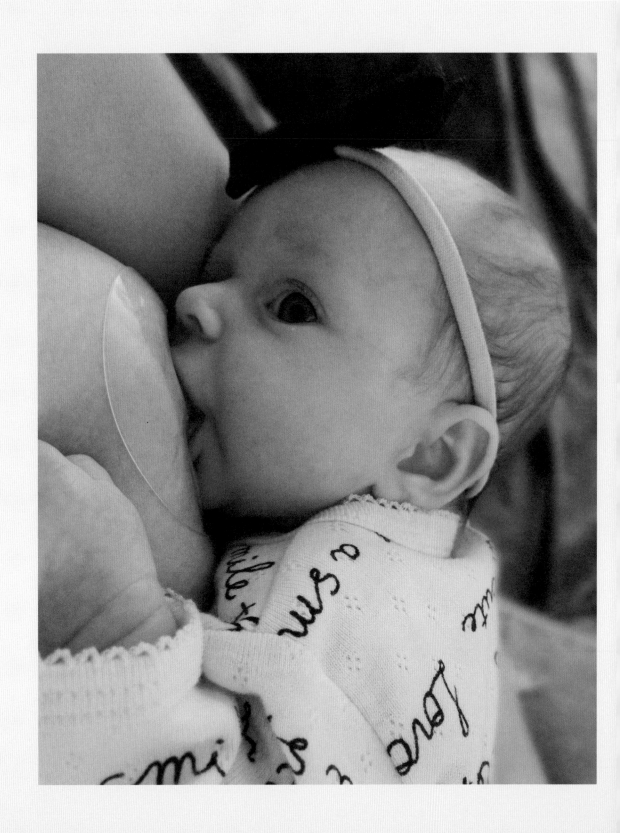

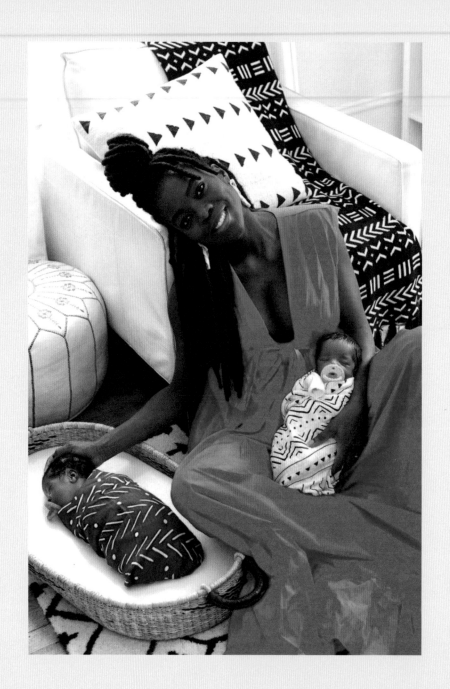

Cynthia Andrew

Here we are! Here they are, Kai and River. I can't even begin to get into what the last couple of weeks have been like. It's been everything and nothing like I imagined. Mostly nothing like I imagined. We are happy and healthy and that's all we could ask for. It's been a journey, mostly for me—the twins have been ready for just about everything so I'm getting all my energy from them. Feeling ready for this new chapter.

First Year

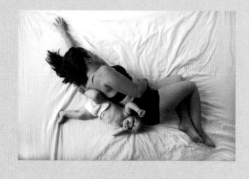

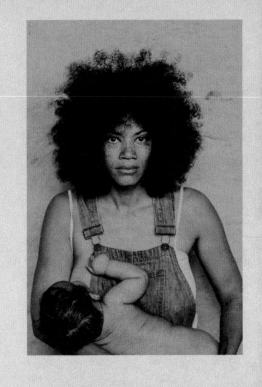

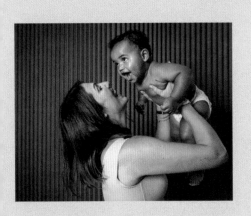

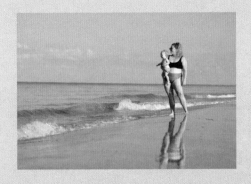

Bianca Williams

I would say that for the most part I had a very positive postpartum journey in the first year after delivering my son.

Breastfeeding went well, infant sleep was an adjustment, but we adapted. I had found a mom community and although my body had changed, I felt strong and proud that I was able to grow and nurture a beautiful human being.

It was a few days before my son's first birthday that my family doctor had ordered bloodwork because I had some odd bruising on my legs. I was told not to worry, that it likely was not anything of concern. It turns out it was. That night, I received a call from my doctor to go straight to the ER.

From that moment my postpartum life changed.

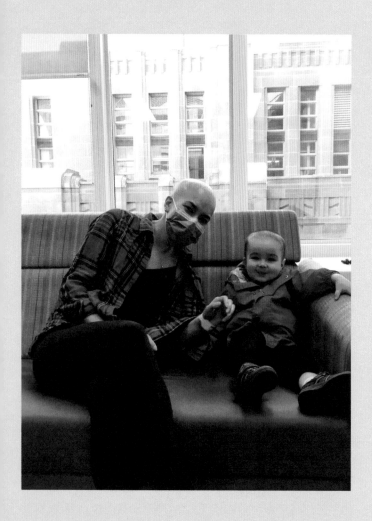

That night I was put on medication by the physician, which meant I had to immediately stop breastfeeding because they could cause issues for my little boy. A few weeks (and many hospital visits) later I was diagnosed with aplastic anemia. My bone marrow was failing. I was in the hospital every week receiving blood transfusions because of extremely low platelets and hemoglobin. I experienced complications that led to me being admitted to hospital. I was always at risk of getting infections. It was discussed that my best option was to have a bone marrow transplant. Throughout all of this, I felt the guilt growing within me—I could not be there for my son how I wanted to be, the way I had been. I was exhausted and I was scared. I would go to work, be at the hospital for hours, and be so tired when I finally got home that I often needed to sleep. My husband was doing it all and kept our family going. But all I could think was I was not the mom or wife I wanted to be.

A few months after being diagnosed, I was admitted to hospital for my bone marrow transplant. I would have to be away from my family for about three months. For the first month after transplant

I would barely be able to see my son at all because such young children were not allowed in the unit. I was petrified that my now 18-month-old child would forget me, that if I could not take care of him, he would not feel my love for him, and he wouldn't love me. These three months were the most difficult time of my life.

I no longer felt strong and proud. I felt ashamed as a mom. I felt betrayed by my body. I felt like a failure.

But, in the end, we made it through. We found a new routine while I was in the hospital. My husband would be sure to FaceTime with our little guy several times a day. He brought me a whole collage of pictures of our family for my hospital room. When I was finally allowed to visit with my son off the unit, he brought him to see me. As this was happening, I was slowly getting stronger. Gradually, I no longer needed the blood transfusions.

I finally got to come home! I was nervous about how that would go. However, I quickly realized that my son had not forgotten me. He still loved me. He was happy to have me back. What I saw was his resilience! I slowly learned that I could be resilient too.

A year later, things are not as they were before. I must still live with the side effects of my treatment. I continue to have moments where I feel ashamed, betrayed, and like I am failing. But now I also see my strength. I see how my husband and son were my ultimate motivation to get better. I know that even if I still have hospital visits or need to rest, I am still a good mother because I never stop loving my son. I also know that the time spent away has given me more time with my family in the long run.

This photo is from when I was in hospital. People would say that I was so strong. However, the truth is that I was scared, ashamed, and heartbroken. I can say that today I am stronger, that I have grown, and I am once again proud of who I am as a mother.

Brenda Stearns

I took this photo when I was seven months postpartum with my fifth child. It's special to me because my abdomen represents everything my body has done for me.
In seven years this body has gone through five pregnancies, two cesareans, and three unmedicated VBACs. My skin had been stretched and pulled, my skin is scarred, wrinkly, and jiggly, my body is stronger than ever, and my heart is bigger than ever, too!

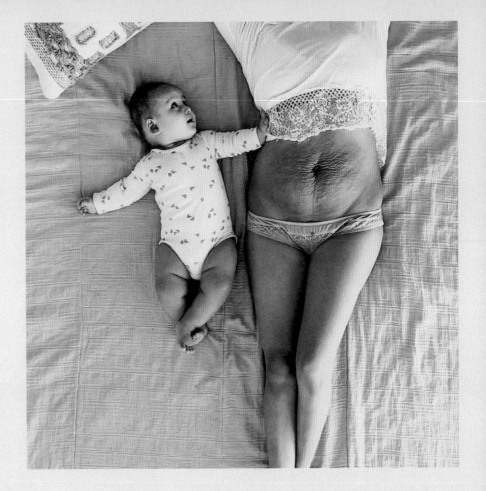

Danielle
DuBoise

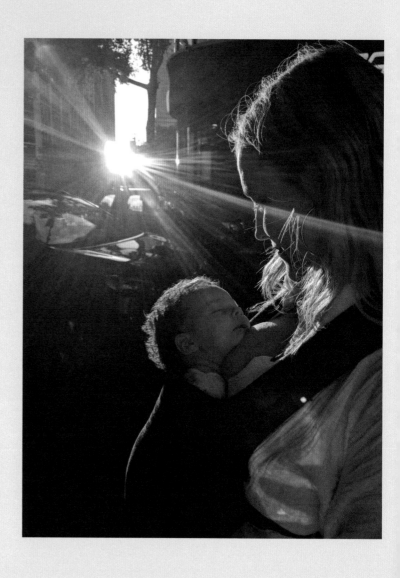

It's the wildest journey I've ever known. So primal, so hard, so beautiful, and so humbling. What a gift it is to usher life into this world—whether that means home birth, C-section, adoption, or just mothering someone through something. It's all an honor to give this much and experience life through this lens.

Elizabeth Whaley

Being a mom in the military is tough. It means spending 12+ hours away from your kids almost every day and savoring those few minutes you get every night during story time. Living for that smile your kids get during pickup at the end of the day, appreciating every little cuddle, and just taking in every moment no matter how small. It also means sacrificing a career to be a better mom, fighting for your right to pump, and fighting for equal parental rights. Breastfeeding in combat boots is far from easy but I wouldn't trade it for anything!

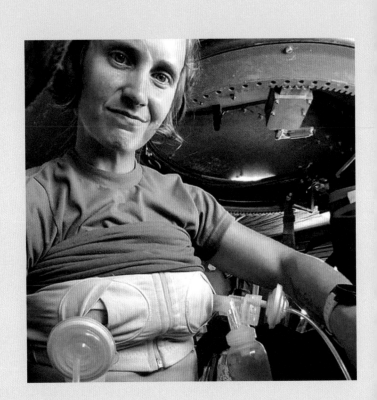

Bria Muller

At this point in our breastfeeding journey my main thoughts were that I didn't ask people's opinions. So why do they think they can give them?

In the same breath people would comment on how kind natured and calm Zebedee is, how we both seemed relaxed and happy. All the positive reasons why we breastfed and co-slept.

Always finishing off the compliment by commenting that he was too old for the breast.

I've never reacted to this. This was our healthy calm place and I made sure not to let others take that away from us. This process taught me that people's comments say everything about them and nothing about us. We learn and we grow together and I believe the benefits of breastfeeding Zebedee will stay with him for the rest of his life.

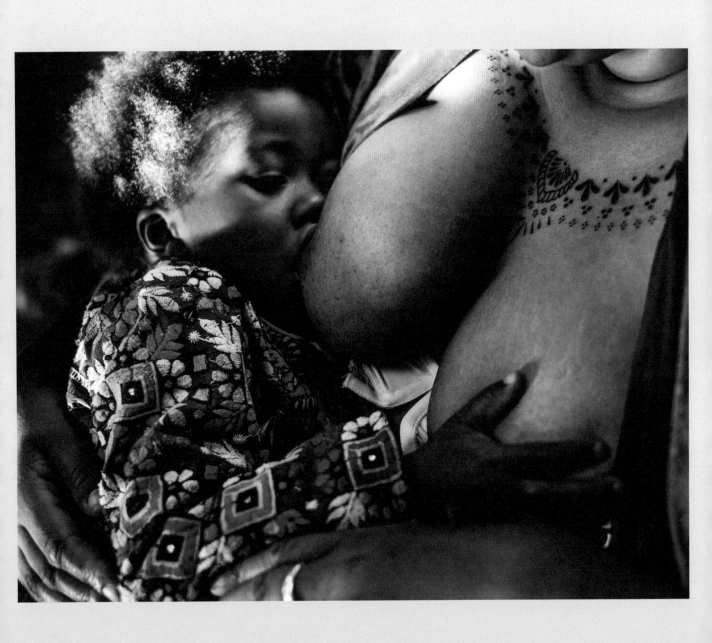

I think the most shocking thing that I learned during the birth process was how okay I was with myself afterward. For the first time I've been okay with my body because it's just done something amazing.

Emily Freiburger

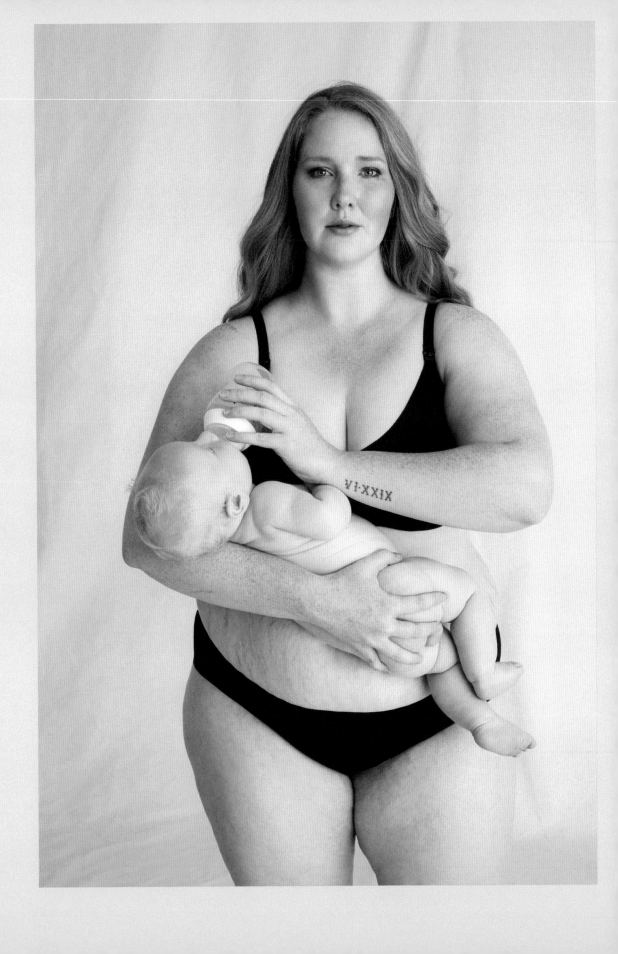

Erica Bayley

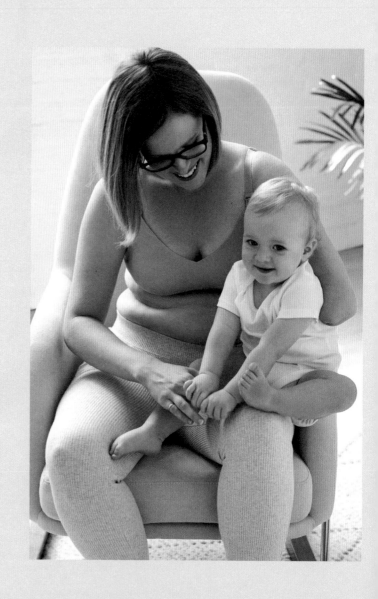

There's no "right" way to breastfeed.
I knew I wanted to try breastfeeding so
I did a bit of research. Turns out having
one hand meant doing the "right" things
was impossible. When my baby arrived,
what I was doing looked nothing like
what was in the books. I was stressing
that by not doing it "right" I'd be doing
wrong by my baby and that I was a failure
as a mom. But my baby was healthy.
It didn't matter that I needed three pillows
and four blankets. If she was healthy then
I was doing it right.

Georgia
Burns

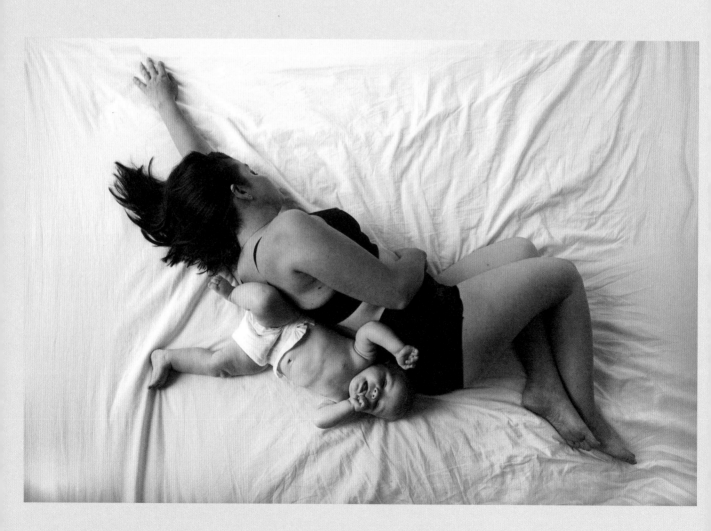

I can hardly believe it's been two years. Everything that is happening right now is bringing the birth experience back.

I had a scary emergency C-section that had a few complications. I felt very isolated at the time and embarrassed that I couldn't have a natural birth.

I processed my guilt and shame by creating a framework for moms to move through childbirth trauma. I've been sharing my work through this global Covid-19 pandemic crisis and it's kept me strong. It's mostly allowed me to mourn the loss of what I thought life was going to be like for these next few months.

After my son was born I had this picture taken to remind me to accept all of the feelings without judgment.

Katie Watkins

I think this photo is f*cking beautiful.

But five years ago? Five years ago I would have cringed
at it. I know this because I did.

When I saw my first postpartum body, it was my own.
And it looked nothing like what I had expected. Nothing
like the limited content I had seen of postpartum life.

Moms completely content, with their perfectly fitting
clothes and their perfect (quiet, clean, happy) babies.

Moms who had "bounced back" and were splashed
across magazine covers for having done so.

None of this was my reality, and as a result, when I was
confronted with my body after birth, I cringed.

But now? Now all I see is beauty. The mess, the pain,
the blood, sweat, and tears.

It's all so f*cking beautiful to me.

I'm so grateful that photos like this are becoming the
new normal, though I'm acutely aware that there are
still many who don't see beauty in these images.

They unfollow. They make hurtful comments. They want
us to be quiet and to cover up.

But this photo is not for them.

It's for me five years ago.

It's for you, soon to be living in a postpartum body too.

It's for anyone who wants to see the real and raw side
of motherhood.

It's for those who think this is f*cking beautiful too.

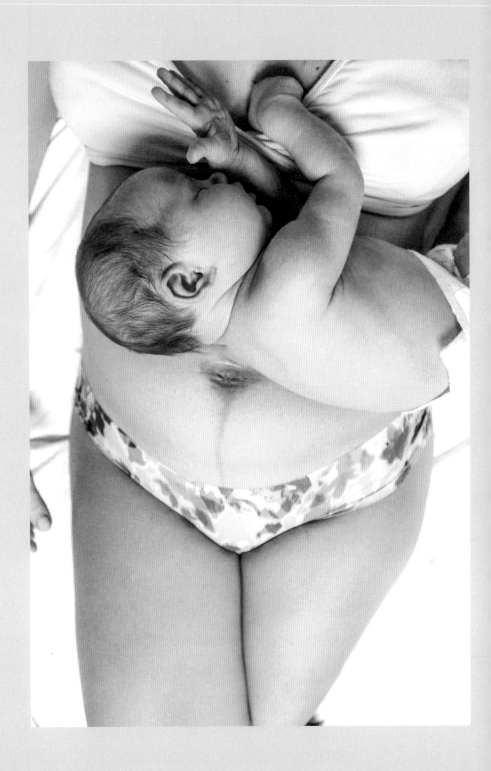

Lindsey Bliss

I was never thrilled about pumping. Here I am taking a quick pump break during a client's birth in the hospital bathroom. Whenever I was away from my baby and I had a letdown, a wave of overwhelming dread and anxiety washed over me. Later, I learned that there was a name for this occurrence, D-MER, or dysphoric milk ejection reflex, a condition affecting lactating people that is characterized by an abrupt dysphoria, or negative emotions, that occur just before milk release. Knowing that this was an actual condition helped me to power through and to continue breastfeeding. I think it may help others to know that not everyone's infant feeding journey is unicorns and rainbows. We're all just doing the best that we can.

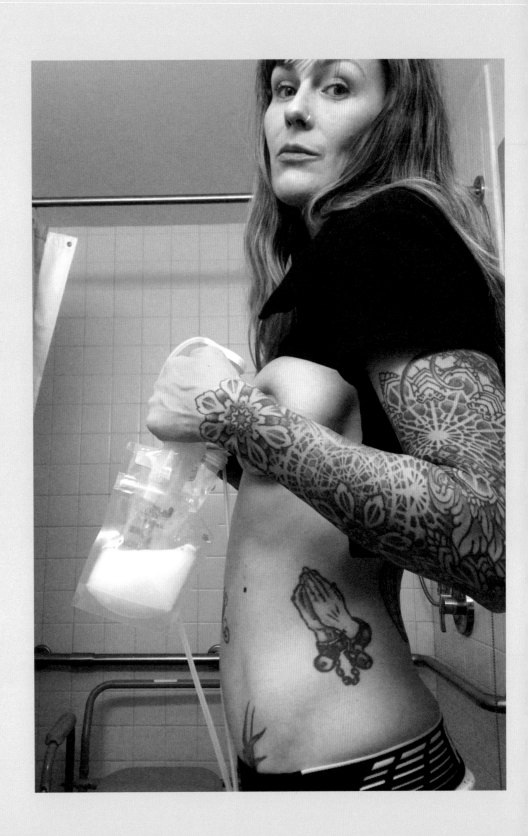

Taylor
Dini

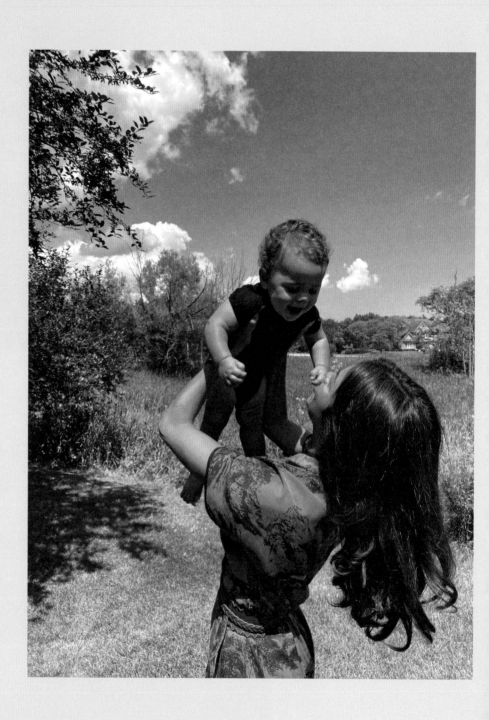

What a journey this boy has me on—full of discovery and patience (lots and lots of it). I never imagined someone so small could teach me so much.

Liz Plosser

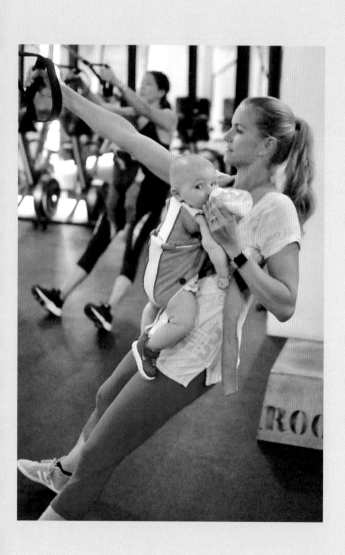

My boy-girl twins are a blur of numbers of milestones. When the hospital sent us home with our 48-hour-old, four-pound babies, I was delirious with joy that they were healthy.

After almost six weeks of bed rest, 35 weeks of pregnancy, and two years of fertility treatments, it felt too good to be true. My husband and I spent the next two months tracking every ounce of milk they consumed, weighing diapers, traveling back and forth to the pediatrician. I was so desperately insistent on celebrating their existence that I constantly felt guilty for being tired, scared, impatient, overwhelmed, helpless—I look back on myself with so much compassion and wish I could give that Liz a long, hard hug.

My third baby came into the world like a rocket ship. He was almost born in the hospital's hallway. I can still smell the cigarettes on the doctor they yanked off of break to bring George into the world. I don't think I ever took the time to process how fast and furious it went down, because of course I was focused on how lucky we were to have a healthy baby. As mothers, we are so focused on powering forward, but pausing to work through the mental, emotional, and physical repercussions of giving birth is equally important.

The postpartum weeks with my third child, George, were wildly different than the first time around with my twins. (They came home at barely four pounds and each required hourly nursing. I have never been so exhausted.) With the benefit of experience and some childcare support, I was able to direct some of my precious energy to self-care. I would never tell a new mom to choose fitness over rest or sleep but I can tell you that moving my body helped me feel more like myself emotionally, mentally, and physically than I ever imagined possible.

Lori Yerry

Do I like my postpartum body? Not particularly, but I am so proud of it. That it was able to carry twins to term and now it provides what they need. Every single day. Nursing twins is not easy. It is not often the magical, wonderful thing you hear breastfeeding mamas rave about. This is work, and there have been days I was ready to quit. Then I remember how amazing it really is. The fact that I have been able to continually nourish two humans with this stretched, saggy, and scarred body of mine, since conception. And for that, I love my postpartum body.

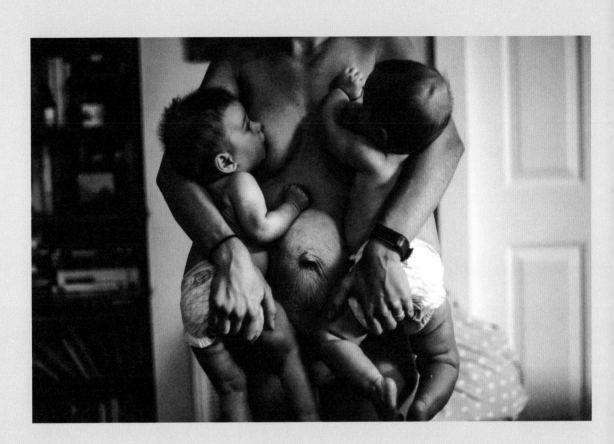

Marie–Lou
Gagnon

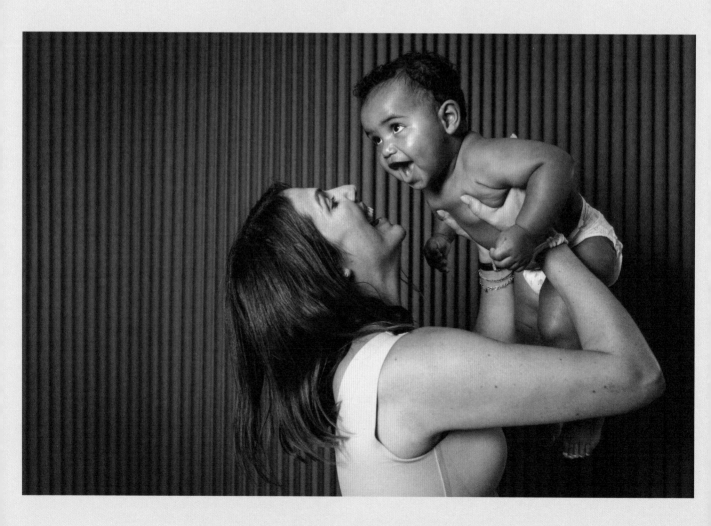

Nothing could have prepared me for postpartum. Never could I have imagined the isolation I would feel, the exhaustion, the pain of an unexpected C-section after a hard labor, the guilt in having failed to deliver my child naturally, followed by failing to produce enough breastmilk to exclusively nurse my child. I recall postpartum with my first child as the darkest time of my life, full of failure, yet contrasted with unconditional love. It took me three years to build up the courage to do it again. This time I would ask for help, this time I would practice self-love, this time I would give my body time to heal without judgment. This time I would not blame my body for failing me, but rather praise it for giving me him. My hips are wider and my C-section pouch is bigger, but none of this matters in my big mamma heart.

Hon. Michaelle C. Solages

Love your beautiful postpartum self through the normality and chaos of new motherhood. Find your strength while chasing this concept called balance. Postpartum might be one of the hardest parts of being a mother, but women were made to prevail, and powerful we will always be.

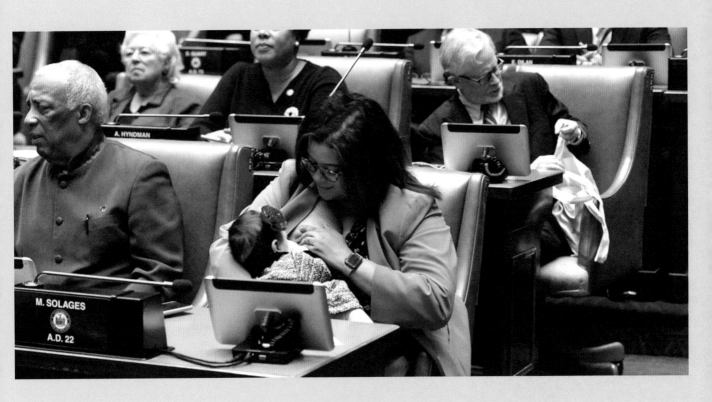

Postpartum is a wild ride and it's a very sacred time for both mom and baby.

Looking back, I felt the need to "jump right back in" to work and keep things moving. As you can see in my picture, I am breastfeeding and still wearing a diaper after labor. I was only one week PP there which is crazy that I felt the need to still stay in the game. If I could give any mom advice during PP I would say enjoy the quiet times and just be in the moment. The newborn stage goes so fast and there is nothing like being able to feed your baby. The hardest part of PP for me was the lack of sleep. I was so freaking tired and that really starts to wear on you. I loved snuggling with Sky in the mornings, and breastfeeding in bed is way easier. But one thing no one really talks about is when your hormones are trying to regulate and the hormonal swings nail you. I felt so off for months and it was really hard to adjust to that way of being. It was a grind for sure. Exercise really helped me—it was encouraging when my body started to return to "normal." I felt like exercise just gave me that release I needed throughout the day. At around seven months I hit another really hard hormonal stretch but with the help of acupuncture I did pretty well. During this time my hormones were all over because my milk was drying up. I remember heart palpitations too, which were so weird and kinda freaked me out. But, during all this I continued to do what I love and managed to continue to create content, teach classes, personal train and be a mom. It's amazing to see what your body and mind can do! I just think there is nothing like bringing a child into this world. It changes you forever. PP is like the ocean: it comes like the waves and some days are smooth while others are rough—it's just the way it goes. I would say that after I hit ten months I really got my stride back and then I got pregnant again. I went on to carry my daughter Palmer Jo until she was 21 weeks. She passed away and it was the hardest thing I have ever been through. So once again I am six months PP but this time without a baby. This round of PP is *no joke*! Totally different from my first. Dealing with loss, complicated grief, and utter heartbreak is something no mom should ever have to deal with. I have fought a lot of battles this round and I am still standing, and that's huge for me. But I can say time does help heal a broken heart and I am feeling better after six months of total torture. Having children has changed me to the core and I am forever grateful for the angels that have chosen me. Being a mom is my greatest achievement and my biggest blessing. Remember mamas, PP looks different for everyone and it's your story to tell. Be gentle on yourself and remember what a miracle it truly is.

Natalie Uhling

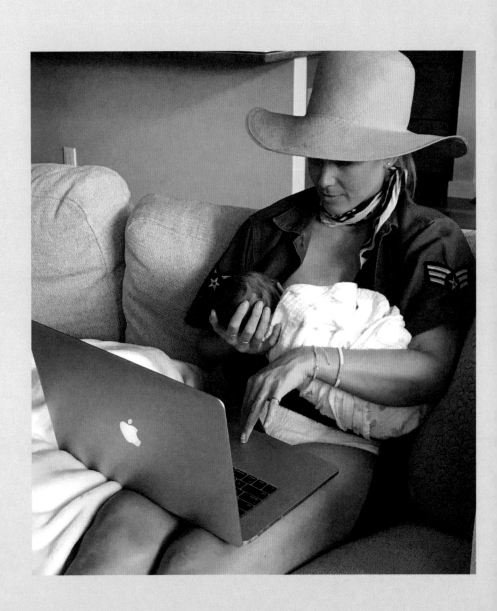

Neram Nimindé

Whether you decide to breastfeed your child or not, whether you choose to do it exclusively or mixed with other feeding methods, whether you go for a short time, something in between, or a long time, please know that it's always only all about you and your kid. Nobody else should have a say or force their opinion on you. You are the mother; dive into yourself, follow your intuition. And I encourage you to have nobody take this away from you because it's yours.

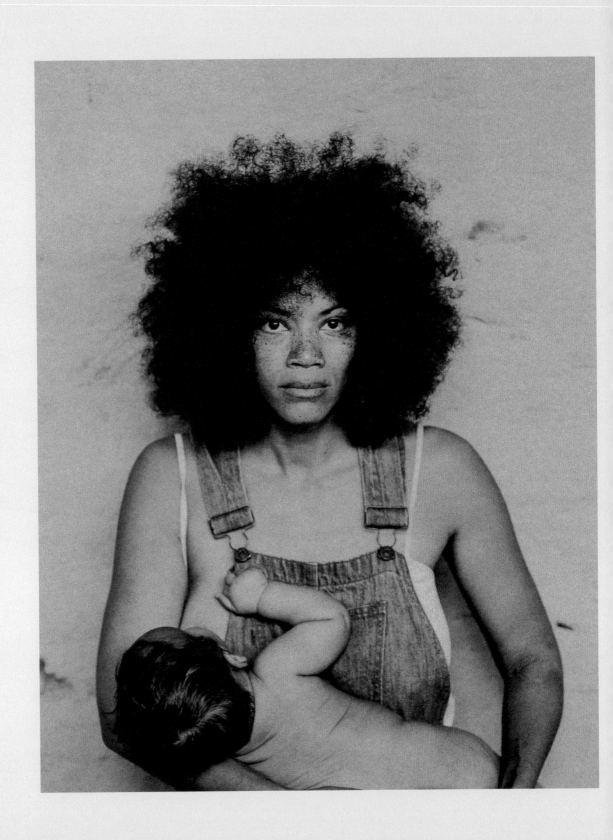

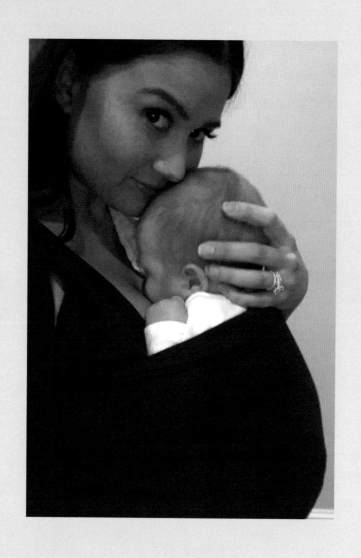

Catherine Giudici Lowe

Before I had babies, I was worried about being maternal. Worried that I wouldn't know what to do or if I would be enough for them. But I am so grateful that the instinct and the full gush of love overcame me, and now I can't believe I was ever nervous.

My pregnancy was complicated emotionally as I never felt attached to the baby yet the thought of something happening to her gave me debilitating anxiety of which I had never experienced in my life.

Soon after giving birth I suffered from postpartum depression, which led me to get on medication for the first time in my life. I had always been under the belief that I was the one in control of my thoughts and moods, and it turns out that having a baby puts you completely out of control with those things when hormones are involved. I struggled with breastfeeding, triple feeding my way through three months of agonizing torture and crying from baby and me. Then last February I discovered I had a thyroid problem, something else to add to the medication plate and the reminder that having a baby completely rocked my body upside down. This photo was taken when Maxine was a little over a year. I am in a bikini (something I never dared before having a baby) on the beach with the baby that changed my body from head to toe, inside and outside, the baby that I had to learn to love over a year of dealing with postpartum depression, a baby I couldn't kiss or tell I loved her for months. Here we are on the beach and we are the best of friends and I am rocking my Mom Bod so hard. It feels good to be where I'm at, knowing where I've come from.

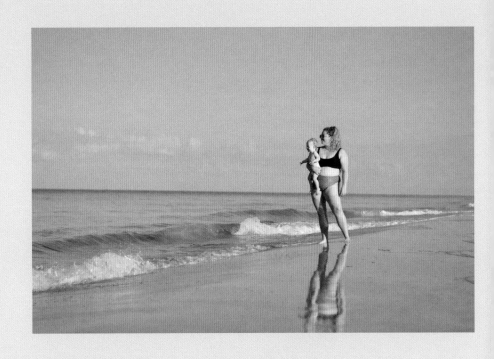

Sadie
Cotton

Sarah Michelle Gellar

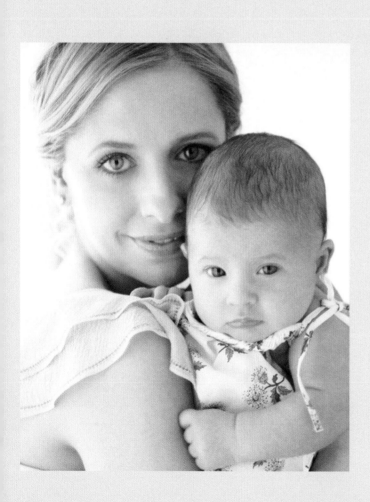

Having kids is wonderful, and life changing, and rarely what you're prepared for. I love my children more than anything in the world. But, like a lot of women, I struggled with postpartum depression after my first baby was born. I got help and made it through, and every day since has been the best gift I could ever have asked for. To those of you going through this, know that you're not alone and that it really does get better.

Tre Watley

This is my life now
and I wouldn't trade it
for anything.

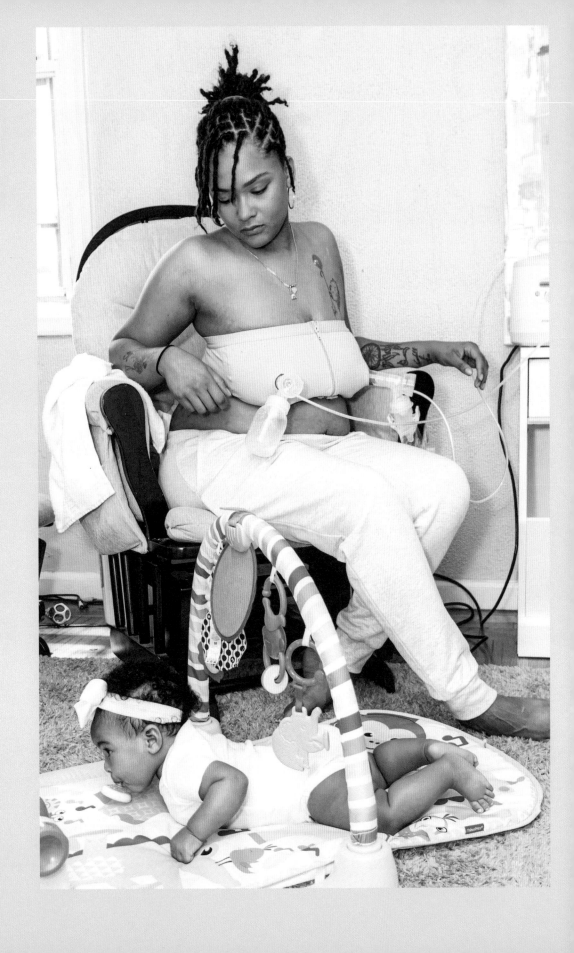

Beyond

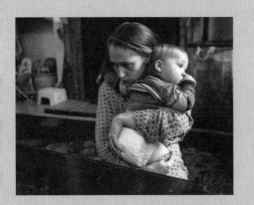

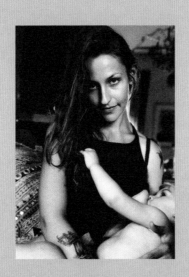

Anupa King

"Unattractive."
"Nothing to be proud of."
"I should have taken
care of my body."

I would be lying if I said reading this about an image of mine over a week ago didn't have me in tears.

It's taken me a week to calm down and here's what I have to say.

I grew up in a culture and society where women were condemned for showing the reality or rawness of their postpartum bodies.

I grew up not knowing what a postpartum body looked like until my own.

I grew up in a home with the strongest woman I know—my mother—but I was never allowed to see her postpartum body.

I grew up in a village where the women were expected to be everything to everyone under her roof.

Wash every piece of clothing used by the household by hand every single day.

Wash all dishes and clean their homes on a daily basis.

Prepare three hot meals every day from fresh produce.

All while having a full-time job.

Above all, they were expected to NEVER show any weaknesses or struggles!

And that's exactly what they did, with zero appreciation for who they are as a person, as a wife … as a MOTHER!

They hid from the world with fear of being unaccepted … being unacceptable.

TODAY, I HAVE A VOICE. ONE THAT WAS SILENCED FOR SO LONG. UNTIL NOW. I'M NO LONGER AFRAID OF BEING JUDGED.

My tears were for this guy who left this comment and all the men out there who disapprove of a postpartum body or any body!

They were tears felt after all of me was reassured that even though I may be one voice, I know I'm most definitely creating an impact, I'm most definitely breaking down barriers, and I'm most definitely enabling WOMEN every day to see that they matter.

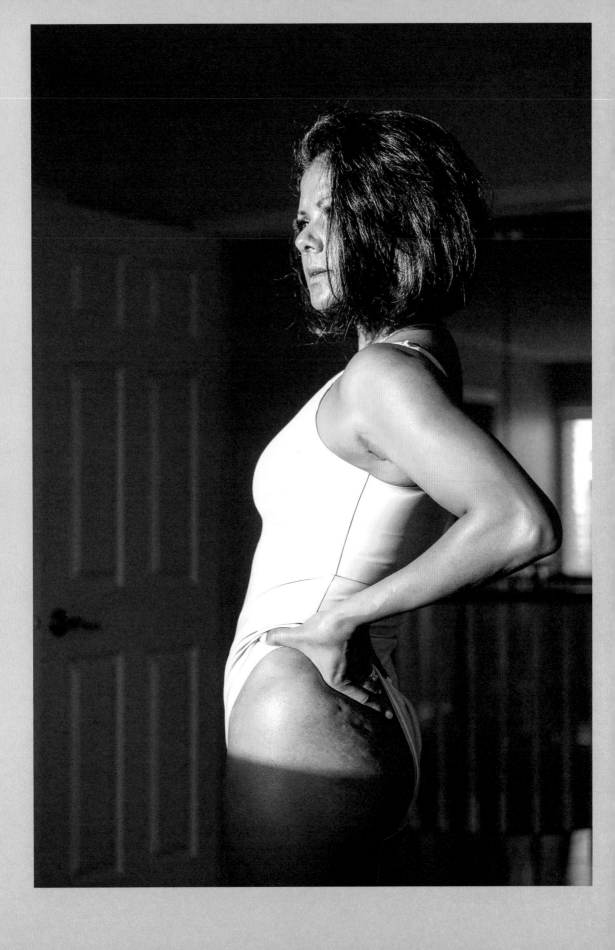

Ashley Bernier

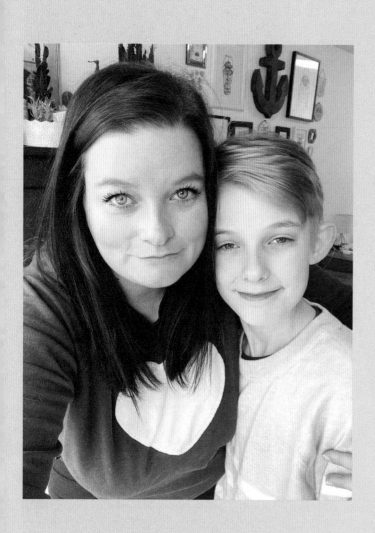

Thirteen years ago we were told we might never have biological children—so two years later when I finally did get pregnant (with the help of some fertility meds), we were overjoyed.

Being a mother was all I had ever wanted. When Hartley was born he completely changed our lives. He was born with intestinal failure—a disease he will have for his entire life. We became his full-time nurses, and later on homeschool teachers for all three kids. I gave up my career and a new version of me came to life. For the last 11 years my main job has been keeping him alive. Motherhood has been about grieving the experiences and the life that I expected—but also celebrating every single moment (big and small) because nothing is promised to any of us—least of all time. Even on the darkest, most difficult days I cannot imagine life any other way. I love being a mom more than anything. I've been so incredibly blessed as a mother. I have three sons who absolutely make my life and a partner who supports me every step of the way.

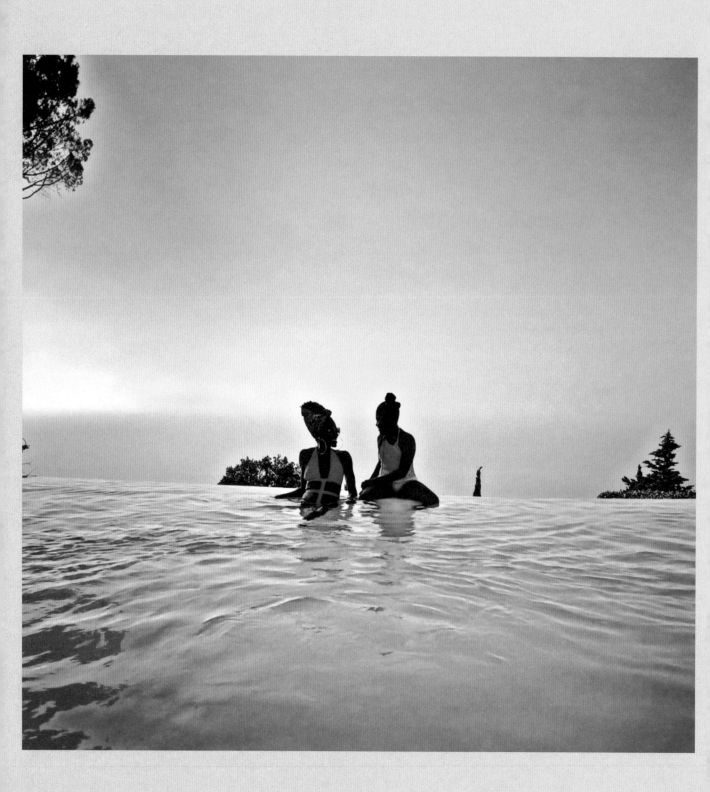

Bozoma Saint John

My love for you is as countless as the drops of water in the ocean, as deep as the depths below, and as far reaching as the unseen horizon.

Catherine Belknap

You know what is hard? Motherhood. You know what is amazing? Motherhood.

You know what is lonely? Motherhood (even though you are never alone, like ever). You know what makes you feel like the biggest failure? Motherhood. You know what makes you feel like you are super human? Motherhood. You know what makes you feel like you are crazy? Motherhood. You know what makes you feel like the most patient person in the world? Motherhood. And guess what makes you feel like the most impatient person in the world, yup, motherhood. You know what brings out your worst side? Motherhood. You know what brings out your best side? Motherhood. Motherhood, it is full of oxymorons, polar opposites, fear, doubt, joy, love, and literally every single emotion in between and some you didn't even know existed. Wherever you are on this motherhood spectrum, from brand new to having grandchildren, all of us feel these emotions. You really aren't alone. So to every person who feels a little alone today, please take this message and pocket it.

The beautiful thing about motherhood is, we should all get it. We are all doing the best we can, we're all mostly exhausted, we're all mostly wondering if we're doing it right, we're all mostly failing at balance, because balance doesn't exist. We're all doing it differently but we're all loving the same.

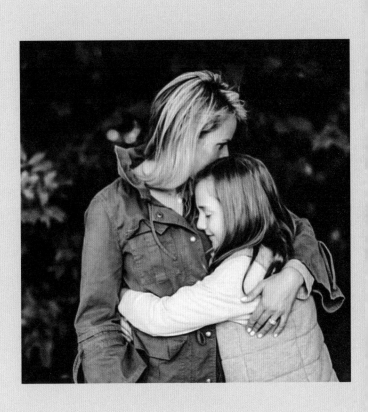

Desiree Fortin

When I found out I was pregnant with triplets, I wondered how my small body would actually carry three babies at one time. My first doctor told me I would have an unsuccessful pregnancy and advised me to selectively reduce. I had to find a doctor to support me and I did. My body stretched and stretched. It transformed into something new and wouldn't be the same. My stomach is covered in loose saggy skin and stretch marks. I call them my hope wounds and they tell a story that brought me my children, three absolute miracles. It's a daily effort to change my perspective and find the beauty that is right before my eyes because it is there.

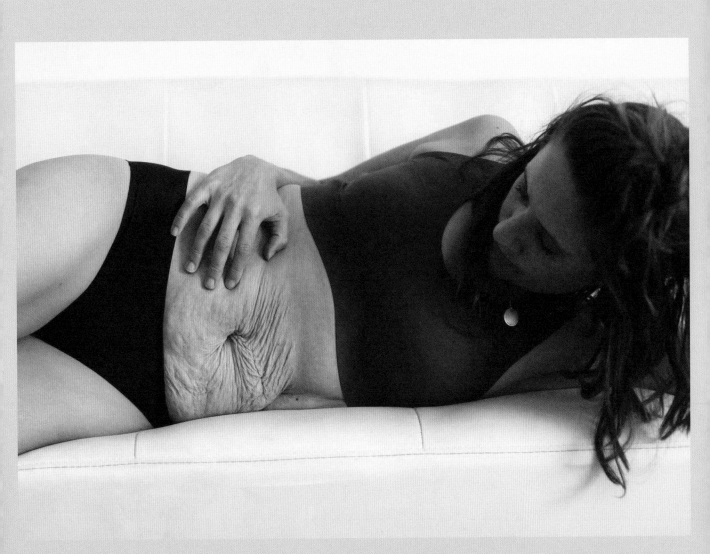

Nobody is born a parent. I spiraled hard and fast after my first son was born. It wasn't just the physical exhaustion, or the grief for my old life. I felt emotionally, psychologically, and spiritually ill-prepared. The parenting books people recommended didn't talk about intergenerational trauma, or tell me that showing up for my child would require faith in myself—faith I'd never had. It takes a village, for sure, but it's much harder to rely on your village when you don't trust yourself.

Domino Kirke–Badgley

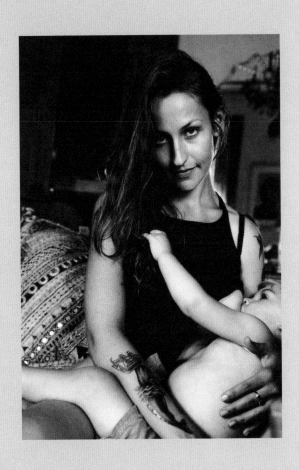

Donna Duarte—Ladd

Our second son, Mateo, was dropped off to us when he was two weeks old and still had the new skin babies have and hadn't been given his first bath. Although young, he was scared and sad—he had already been through so much. I immediately felt this was going to be "our baby." The process was hell, and I never felt so raw. When we adopted him at thirteen months, we were all a hot mess at family court, including our caseworker. Of course, the journey was completely worth it.

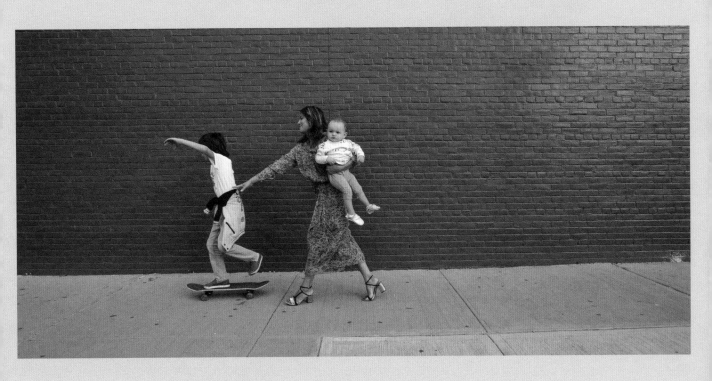

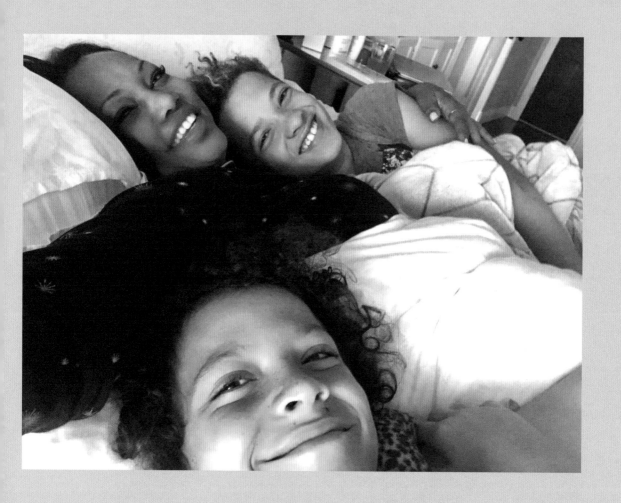

A mother's love is whole no matter
how many times divided!

Garcelle
Beauvais

Valeria Lipovetsky

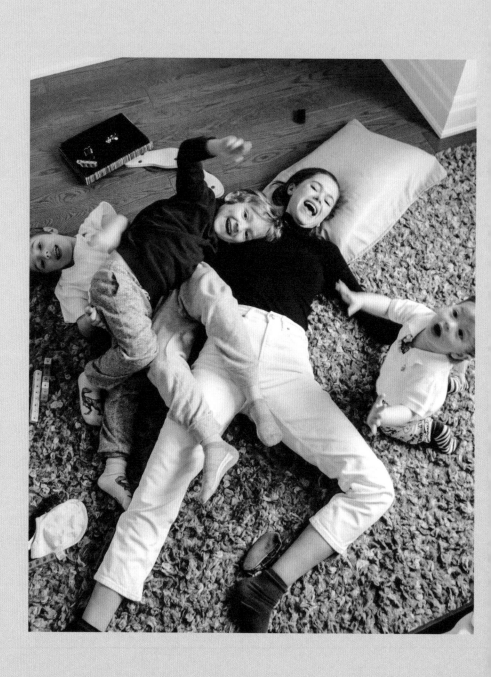

If there's one thing I love most about being a working mom it's that you really get to appreciate all those little random moments with your kids, and they become that much more precious ♡. I'm grateful to be able to do what I love and reach for my fullest potential while raising these amazing boys. I don't take it for granted for one second and I praise the women who paved the way for us to have all these options and opportunities.

I'm a type 1 diabetic and the proud mama to Callie—our little warrior princess.

Callie was born with a chronic heart condition and due to a lower limb difference had to have her leg amputated at 18 months old. Here's some of our postpartum journey.

There is a unique kind of grief that comes along with being the mama of a child with special needs. For me, the grief has come in waves. At the beginning, they were threatening to overtake me—constantly pulling me underwater while at other times softly ebbing and flowing—giving me the chance to get my head above water.

I would be lying if I said I didn't imagine how our life would be once Callie was born. Big, grandiose, elaborate dreams.

And then life sidelined us. Knocked us off the path that I had dreamed of and planned for us. Onto this completely new path. And the path it knocked us onto? It turned out it was much harder, scarier, and we didn't have a damn map for it. No one we knew had walked the path before and we were alone on it. Lost. We now had a child that had a chronic heart condition and was a lower limb amputee.

I grieved for small things. I didn't get to take maternity pictures with Callie because she was born so early. After she was born if I saw a beautiful maternity photo session, it would send me into a tailspin of depression. We didn't get to send out a birth announcement or do newborn photos because Callie spent the first three months of her life in the NICU. Getting birth announcements in the mail for the first few years would gut me. The beautiful pictures marking another family's joyous arrival of their healthy baby would rip me apart inside and I would have to quickly throw them in the trash to not have a physical reminder. A reminder of what we didn't get to have and what the first few months of Callie's life was not. Seeing other babies' first steps, healthy baby milestone check ups, first soccer games, cheer camps, and learning to swim—even hearing about others' normal daily lives would bring it on. Seeing other kids running to their mamas. Kids jumping into swimming pools. All triggered waves of grief. Grief for an experience we didn't get to have like everyone else.

It has taken me years to understand that it's okay to grieve for what I thought would be and isn't. I used to pair the grief with guilt. How could I grieve for something when it's Callie who has to deal with this stuff? Could it have been my fault we are even dealing with this in the first place? Why was I still upset years later? Shouldn't I have been able to move past it by now? How can I be grief stricken when we have been so blessed?

The grief isn't something that will end and I know that now. I know that sometimes the tides will rush in to overtake me, slamming against me with incredible force. Other times, they will lap at my feet and then recede quietly. Sometimes I will go for months without thinking about it and other times we will simply have a bad day. It could be an anniversary of a surgery, I will see something on social media, or we will just have a life experience that we have to deal with and boom. The tide swells and grief is ignited. I'm swept out to sea fighting to keep my head above water. Now I understand that it doesn't make me a bad mama or mean I love our little miracle any less. It's an emotion that I acknowledge—and then bounce back.

Because, ultimately, that's what life is about. The bounce back. When you are getting knocked down and drug out, it's the times that you stand up that are important. It's the realization that this is now the path that you are on and you have to own it. You have to bloom in the garden that you've been planted in. You can acknowledge the grief but you can't drown in it. It's the realization that it's not the choices we've been given but how we react to them. It's the realization that I'm not invincible but we are resilient. It's the realization that we aren't inspiring others because we have the perfect lives. We are inspiring people with how we deal with our perfectly imperfect lives. It's the realization that all of these scars we are collecting are giving us a greater gift—the strength, courage, and tenacity to overcome them. It's the realization that comparison is the thief of joy and learning that our milestones and triumphs may be different than others—but nonetheless special. It's the realization that we were blessed with a little wildflower among a field of roses. Some days it storms, and some days it shines. This is how flowers grow. And it's time to BLOOM.

Jaime Cline

Jamie—Lynn Sigler

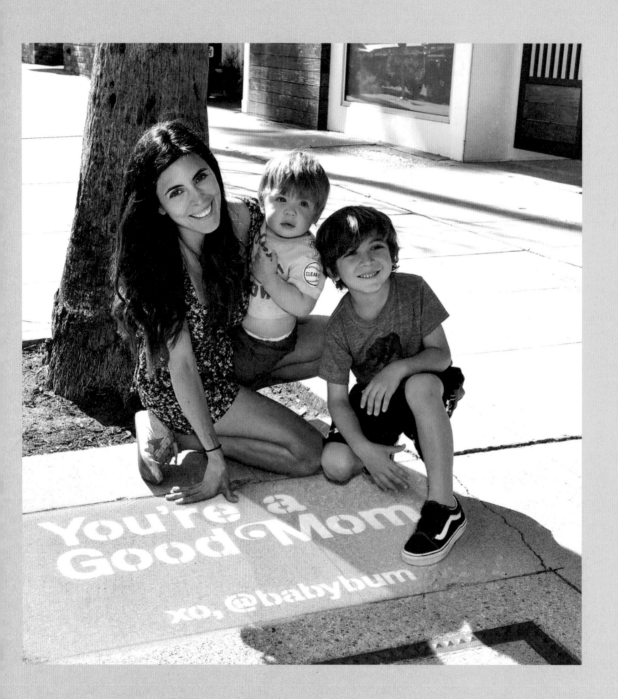

Sights from my family stroll: "You're a good mom." Honestly, I don't think I knew how much I needed to hear that. Between the sleepless nights, the early morning carpools, the dirty diapers, the spilled spaghetti, the cooking, the bottle washing, the self-imposed pressure to be "on" and strong at all times, I'd be lying if I said I never worried about whether I'm doing a good job. When my physical challenges make days harder than others, I have these harsh conversations with myself wondering whether I'm holding my kids back from something better. Affirmations come in many forms— watching Beau laugh as he plays catch with Cutter in the backyard or listening to Jack snore peacefully in my arms—but something about being reminded "You're a good mom" so matter of factly … that really knocked the wind out of me and made me smile.

"When he heard the child cry, a terror possessed him, because of the echo of the unfathomed distances in himself."

—D. H. Lawrence, *The Rainbow*

Jemima Kirke

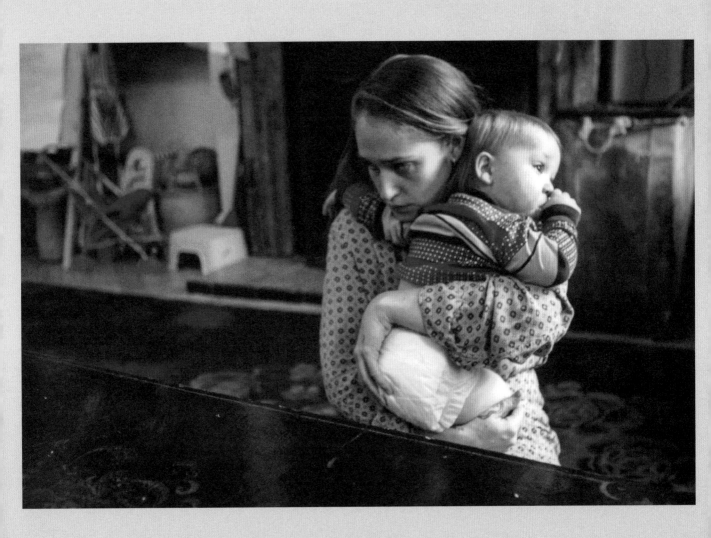

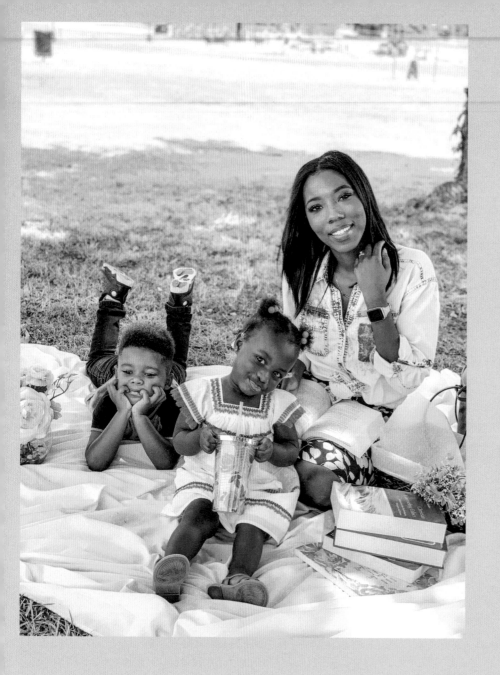

These faces are my motivation. They encourage me to keep it moving when I'm tired, when I don't feel like doing it, the sleepless nights, the studying, it's all for them. I want my son to see that he has a strong mom and not be afraid of a strong woman. A woman who also brings cards to the table. I want my daughter to know that she can have it all, do it all. She can be a bomb wife, good mother, and business woman. I'm setting the standard for them. I'm showing them something I didn't have myself. I'm building a new generation with my babies.

Jessica Hall

Jessica Zucker

#IHadAMiscarriage

I had a second trimester miscarriage.

This is a fact of my life.

An experience that changed who I am.

Pregnancy after pregnancy loss changed me all the more.

I have no shame.

No self-blame.

No guilt.

I did nothing wrong.

I did nothing to deserve this.

My body works.

I don't feel it failed.

I embrace my grief fully and allow it to wash over me.

I grieve still.

I don't believe rainbow babies "replace" our lost loves.

When we lean into heartache, we evolve.

When we work vigorously to stave it off, we drown.

I don't believe everything happens for a reason.

I know I am not alone, nor are you.

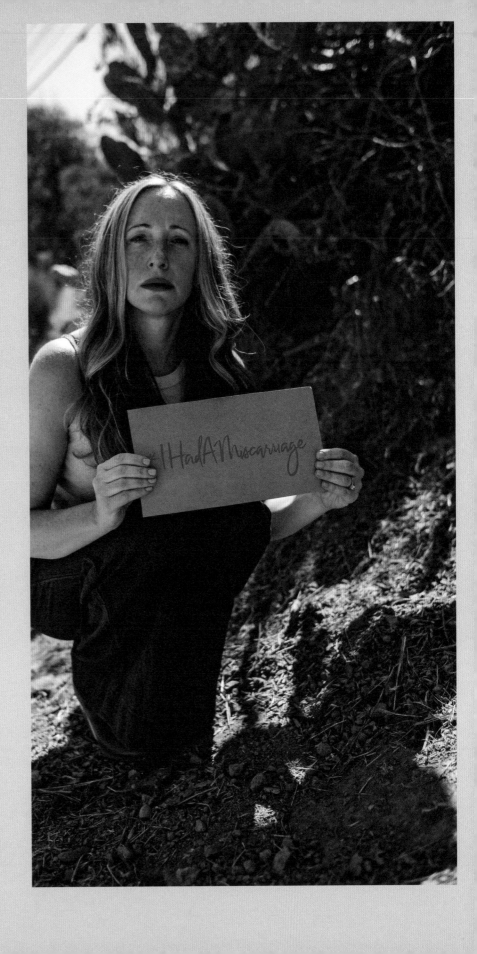

My journey took me through infertility to adopting our son, to becoming pregnant as my dad was dying of cancer, to giving birth to our daughter by emergency C-section because her heart rate was too high, to sadness, to infertility, to brain surgery to menopause (and fibroids), to sadness, to a full hysterectomy in February this year and coming out of it feeling stronger and more powerful every day.

This photo was a symbol as I was starting into menopause and turning 50 last July and my daughter became a young woman in April last year. Power, strength, and connection.

Joanne Ferguson

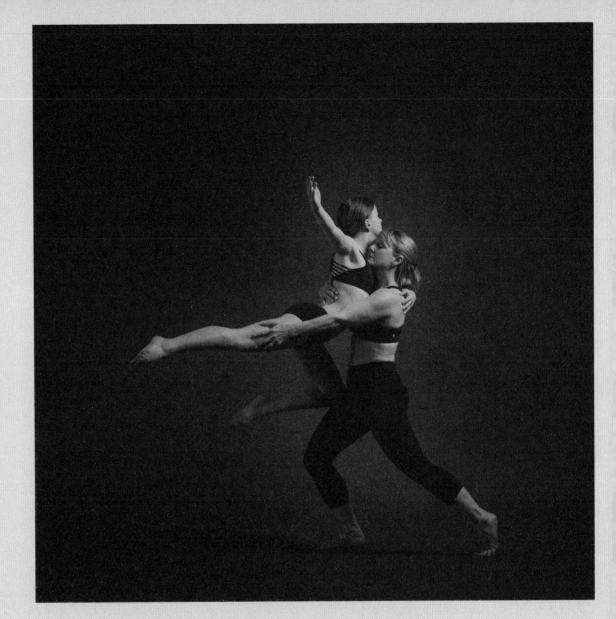

Karen Greve
Young

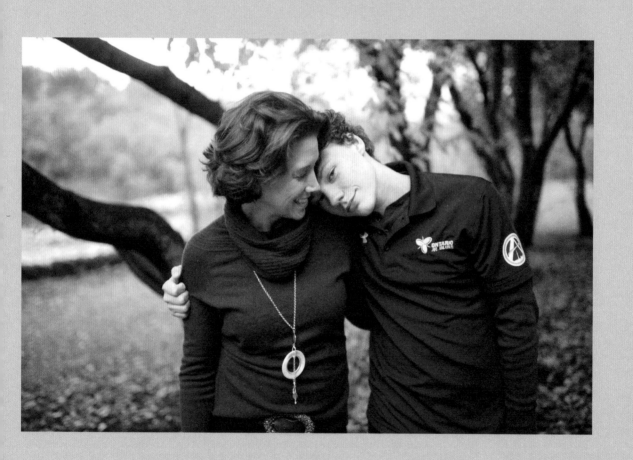

I have a theory that for most women one of the stages of having a baby is especially hard—conceiving, pregnancy, delivery, new motherhood— while all have their challenges.

In my case, I've always thought that the hard stage was conceiving, and it took months of medical magic for both of my kids.

But that's only the most significant medical part of my journey. I lost my mother when I was 26 weeks pregnant with my son, my first baby who turned 15 this summer. After four and a half years with ovarian cancer, my mom lived just long enough to learn that her first grandchild was a boy and got to share his name, Jeffrey Walker, with her friends, and just early enough in my pregnancy that I could fly from London to Washington, DC, to be with her in her final days. An incredible gift for which I'll always be grateful. So for all that I have physical memories of my first postpartum experience, my most significant memory is of how my son helped me through my grief. It's such an incredible time in my life—as it is for all of us—and I've indulged in thinking so much more about those first days during these recent ones.

This is me and my nearly 21-month-old daughter, Evan, during a particularly clingy day when she insisted on joining me in the bath.

As all mothers know, there is no such thing as personal time or space when you have a kid. I know 21 months may seem a little long to be considered postpartum to some, but I'm still feeling it. I still have PPD, melasma, and an array of other pregnancy and birth-related issues I imagine will stay with me for years, if not forever. The relationship with my partner was strained to say the least, and not for lack of trying to get along, but everything is turned upside down when a baby comes along in ways that you can't even imagine, and no amount of reading up or "preparing" can truly prepare you for the reality. Of course it's the best thing that's ever happened to us, of course we wouldn't change it for the world, but that doesn't mean that we haven't been found rocking back and forth crying on the bathroom floor from time to time. Postpartum truly is forever. There's a Sanskrit phrase, "*Tapas*," which means fiery cleansing. A sword is beaten and battered and put through the fire in order to become the strongest sword possible. When we become mothers, we go through a fiery cleansing and, although we don't come out unscathed, we are the strongest beings you'll ever meet.

Kat de Naoum

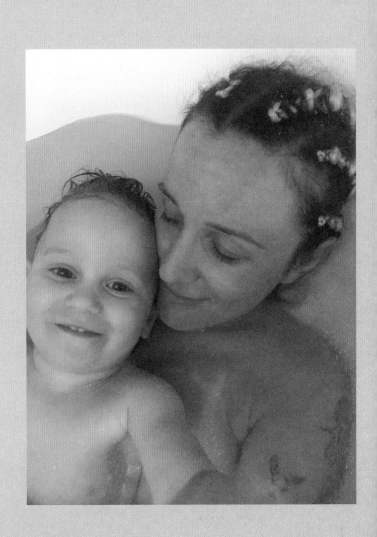

Kristen Bell

Had a pretty busy day making my kids
hold up some extra sun cover so I could
stay on this beautiful beach A.L.A.P.
(As Long As Possible).(I just made that up.)

(Yes, my four-year-old is actually holding
that palm leaf.)

Lauren McPhillips

This is my life not after birth. I chose not to have children, a choice that I've always been sure of, but that also carries the heavy assumption that I'm selfish because of it.

I chose not to give birth, but that choice doesn't define me. It doesn't mean my life isn't filled with love and giving. I'm a caring partner to my husband, a doting aunt to my two nieces, a friend, a daughter, a sister, and a mentor. I host networking groups connecting women in business and have built a brand whose sole purpose is to help other people find self-love and happiness in their own lives.

And although my choice doesn't define me, it is one of the things I find most beautiful about being a woman—that I can have the greatest respect and admiration for mothers without ever wanting to be one myself.

Maeonya R. Watson

I'm a proud baby-wearing mama!

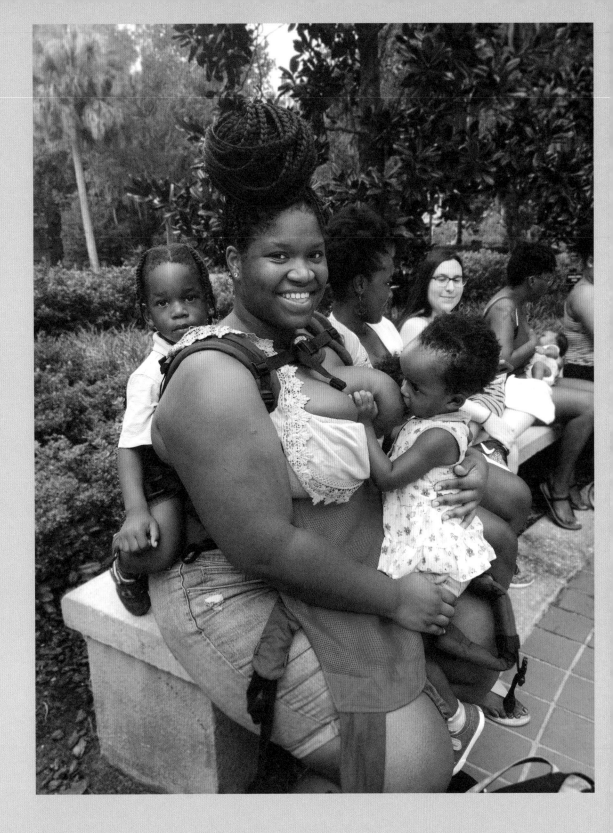

Dear Emma,

You are my little soulmate, daughter, best friend, mini me, and one of the true loves in my life.

The moment I found out that I was pregnant with you, my life changed for the better. I always had an unsettling feeling in life—like my little world wasn't quite complete. The moment I found out I was pregnant, life felt complete. I walked around happier and lighter from that moment on. You became the center of my universe before we even met and I felt an immediate deep connection with you. You entered this world so sweetly and easily. The moment I saw you for the first time it truly took my breath away. We've had an unexplainable connection from day one. You are truly the sunshine in my life and you bring me more love and happiness than you'll ever know. Thank you for being you. You're sweet, kind, caring, thoughtful, smart, and funny. You have a truly good heart. Thank you for changing my world for the better. I'm forever grateful for you and feel so lucky every single day. I love you with all my heart, larger than this entire universe. I had no idea a love this deep could be possible. I love you I love you I love you!

Leah Goldglantz

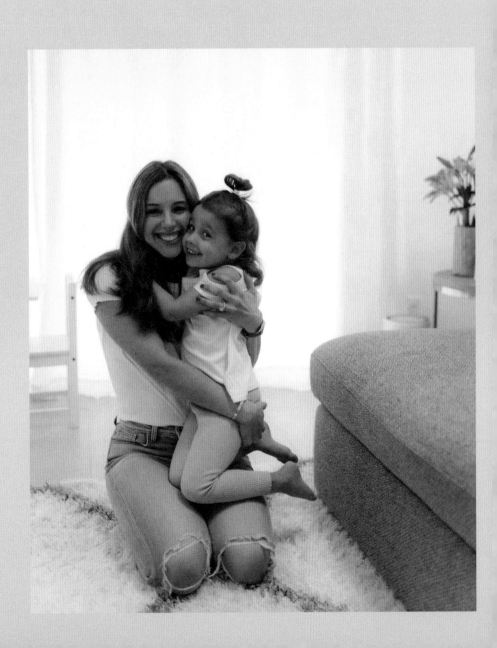

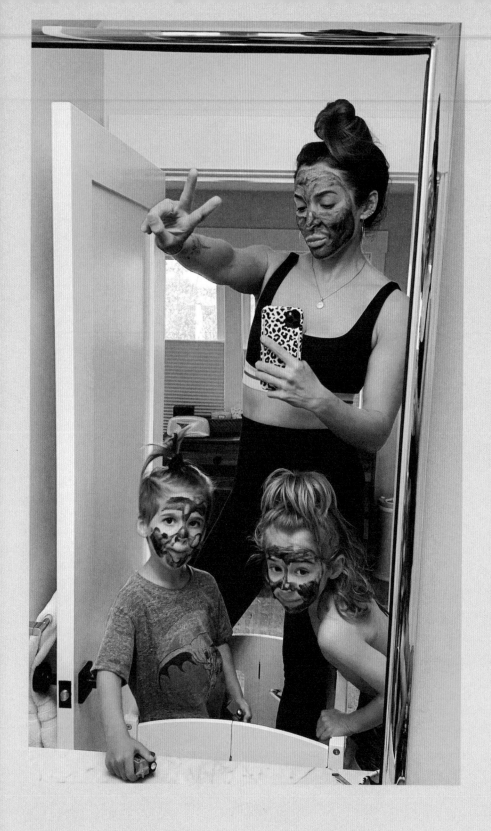

Nicole Keshishian Modic

My boys are now three and five, and while some parts of my pregnancy journey feel worlds away (because we are now over here doing face masks together!!), some of it feels like just yesterday.

My story begins as a broken young woman, plagued by a 15-plus-year eating disorder that essentially took away my life, my womanhood— I did not have a period for all of those years, and was told by many doctors that my eating disorder caused so much damage to my body that I would never be able to have kids. I slowly healed from the eating disorder, but the period never came back. I had to undergo so many rounds of Clomid fertility treatments to get pregnant with Gavyn. Lots of heartbreak over failed rounds. But once it happened, I knew I was not broken

at all, but that the living being in my belly was going to be my firstborn guardian angel. And indeed that's what he was, because after he was born, my period came back, making my ability to get pregnant with Hunter much easier. My postpartum days were long and hard, as they are for all moms. I was happy, yet sad, and happy and sad. One moment crying tears of joy and other moments crying tears of exhaustion and sadness and defeat. I also struggled with my body and how it looked after birthing two boys, from having a flat, toned tummy to a jiggle that never went away. I felt embarrassed in my skin for a long time, until one day I decided to own every single part of who I am. Perfection doesn't exist, nor is that something I want any woman to feel pressured to feel or aspire to be. The moment I began loving myself for all of my imperfection is also the moment I started becoming a more present and loving mom to my boys.

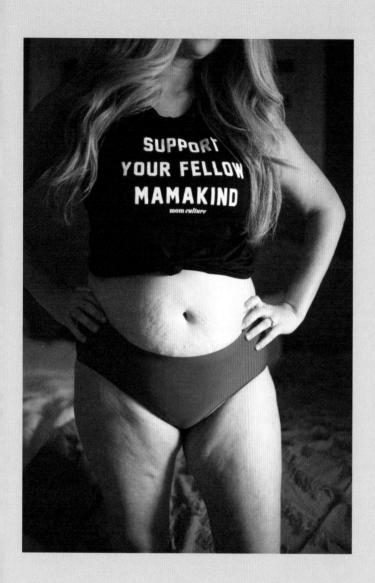

It's taken me 38 years, 30 extra pounds, and three beautiful children to feel at home in my skin. It's funny how motherhood changes you. It gave me self-confidence and a love for my body that I never possessed before.

Sarah Komers

Nyakio Grieco

Oh, how I prayed for you ... to come and complete our family.

A sibling for Lulu, a son for Daddy, and the boy who would absolutely steal my heart. The pregnancy took a little while to happen, but the moment you arrived (a little early of course), on my favorite 11-11 no doubt, you confirmed that wishes really do come true, to never give up, that miracles do happen, and that patience is a true virtue. Thank you for your kindness, your giant heart, your questions that make us all think, your hugs and kisses that are unmatched, your dance moves, your humor, your spirit, your generosity, your energy, your wit, and that giant brain of yours. I love how you love soccer, your family, your friends, math, reading, art, music, dancing, and living life to the fullest. Thank you for making me a "boy" mom and choosing this family. So proud of you Rocco and the incredible young man you are growing up to be. We are so proud of you.

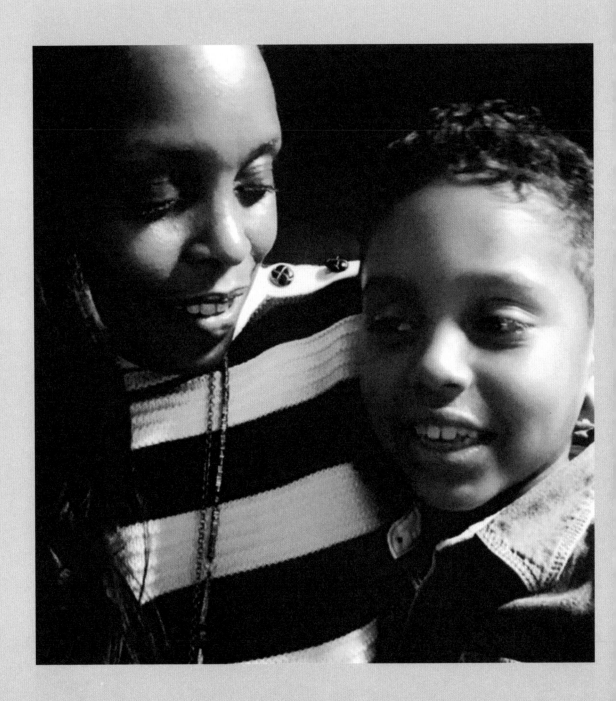

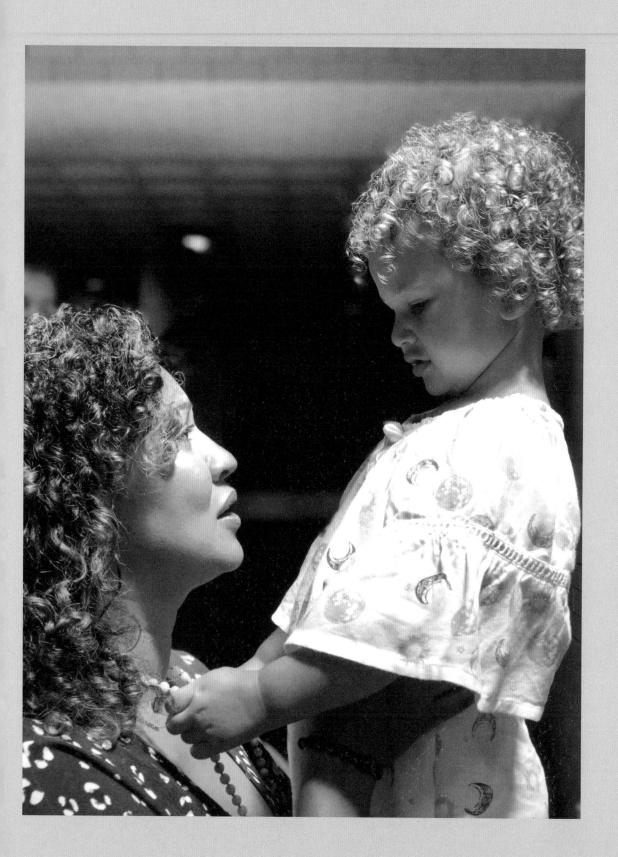

Quisha Freeman

I think our ancestors had a built-in support system with a family and community around them. Yet our generation, which has "moved away," has to create their own—which is hard. You have to take care of yourself and your family more independently than any of the women before you did. I feel like that's why postpartum is so exhausting; we are doing a job that is usually shared with several people.

From mom to mom, I see you.

Jasmine
Pachar

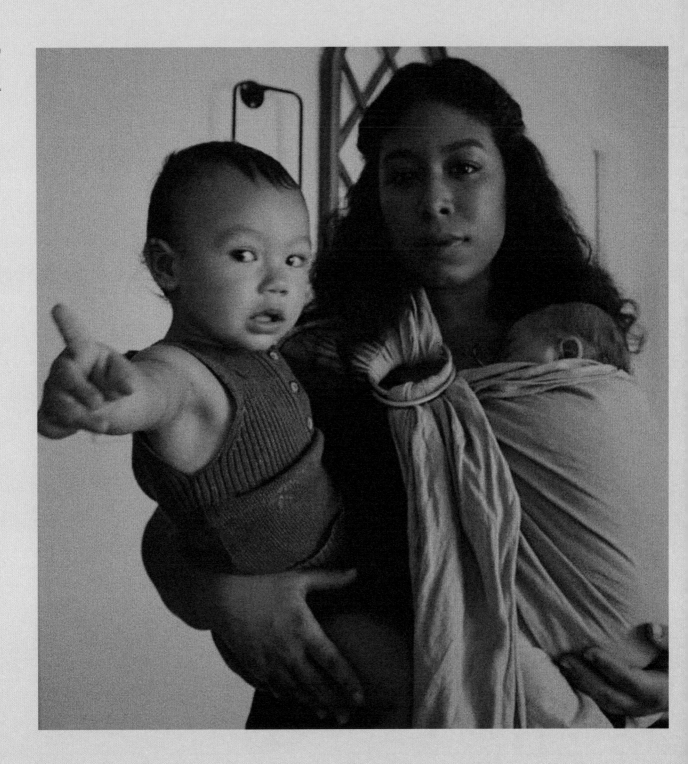

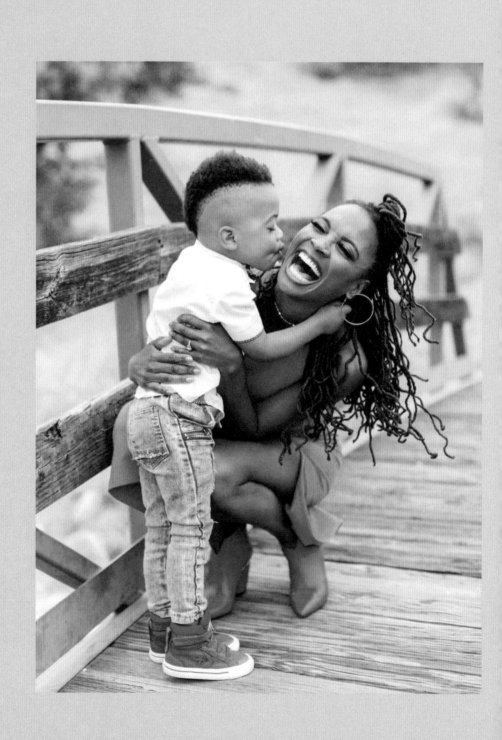

Words can't explain how much
joy this little guy has given me!

Shanola Hampton

Sarah Nicole Landry

When they grew inside me I felt this sense of purpose. Meaning. Motherhood. Growth. Beauty.

Doors were opened for me.
People would stop and admire it.
They would compliment and encourage and tell me how beautiful I was.
What a blessing this all was.

Then when it was over, I felt and looked—deflated.

And it was like all the things that filled me up were gone.

It took almost a decade to stop feeling ashamed of my softness, my stripes, my scars.

And to start seeing and owning my strength, my power, my worth.

To understand that my purpose was never in just being a vessel of life, but to be a vessel of hope and truth and a whole lot more.

I started opening my own doors.
I started admiring myself.
I started to compliment and encourage and remind my reflection of how beautiful she was.

I took myself back from the hands of the world.

My body, my own.

And I stopped feeling sorry for the way my body reacted to it all.
I started to thank it instead.

My body, my purpose, my strength, my beauty, my growth, my meaning.

My own.

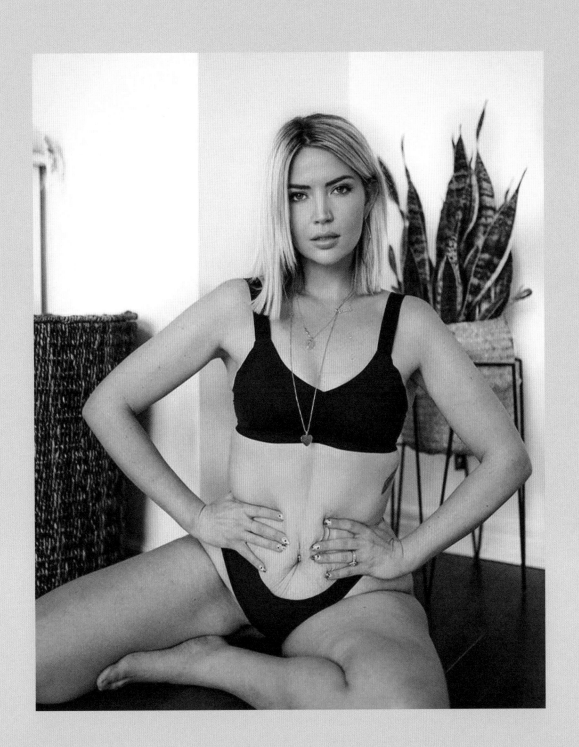

Shout out to all the moms out there trying to nap while nursing but instead you are awoken from your slumber by a little finger up your nose.

Shelby
Rabara

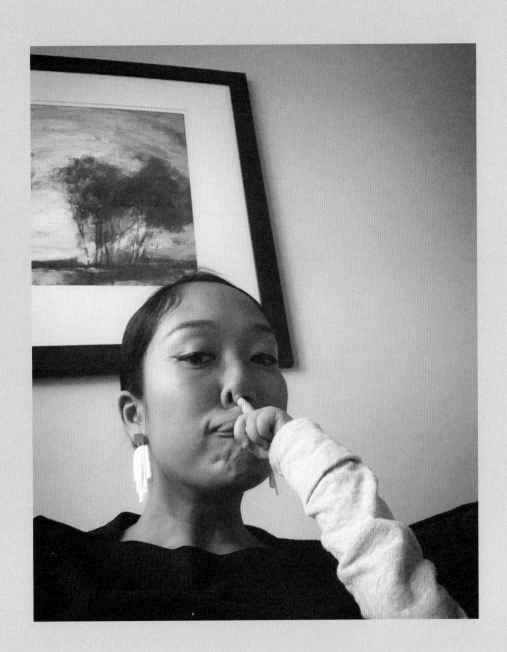

Acknowledgments

This book would not have been possible without the help of our community. Thank you Daniel Melamud, our editor at Rizzoli, for making that long trip to Los Angeles to see the Life After Birth photography exhibition and for guiding us along the way to create something even better than we could have imagined. Thank you to Charles Miers, the publisher of Rizzoli, for sharing this important new narrative on motherhood and parenthood with the world. Thanks to Ken Deegan and Brankica Harvey for the beautiful and thoughtful design, and to the Knix team, specifically Laynna Meyler, for all your work behind the scenes. Finally, to the 116 contributors from the Knix and Carriage House Birth communities who gave us the honor of sharing their stories: this book is the output of your collective journeys.

While birth is a positive experience for many, it's not for all—especially Black birthing mothers. Black and Indigenous mothers in the United States are two to three times more likely to die from pregnancy and childbirth-related complications. And the maternal mortality rate in the United States is only rising. We believe that every person deserves access to pre- and postnatal care. Because of this, 100% of the Knix and Carriage House Birth proceeds from this book will be donated to help support the training of Black birth support workers.

For more information please visit
knix.com/lifeafterbirth

Credits

Abby Epstein
Story credit to Abby Epstein,
Director and Producer,
The Business of Being Born
Photography credit to Paulo Netto

Adilah Yelton
Story credit to Adilah Yelton
Photography credit to
Devynn Leanne Photography

Alyssa Garrison
Story credit to Alyssa Garrison
Photography credit to Scarlet O'Neill

Amanda Chantal Bacon
Story and photography credit
to Amanda Chantal Bacon

Amanda Shuchat
Story and photography credit
to Amanda Shuchat

Amber van Moessner
Story credit to Amber van Moessner
Photography credit to Heather White

America Ferrera
Story and photography
credit to America Ferrera

Amy Nelson
Story and photography
credit to Amy Nelson

Amy Schumer
Story and photography
credit to Amy Schumer

Anita Hickey
Story and photography
credit to Anita Hickey

Anupa King
Story and photography
credit to Anupa King

Arelys Hernandez
Story credit to Arelys Hernandez
Photography credit to
Bumble-B Photography

Ariel Kaye
Story and photography
credit to Ariel Kaye

Ashley Bernier
Story and photography
credit to Ashley Bernier

Ashley Graham (Cover)
Photograph courtesy of
Ashley Graham

Ashley Graham
Story and photography
credit to Ashley Graham

Bianca Williams
Story credit to Bianca Williams
Photography credit to
David Williams

Bozoma Saint John
Story and photography credit
to Bozoma Saint John

Brenda Stearns
Story and photography credit to
Brenda Stearns, @she_plusfive

Bria Muller
Story credit to Bria Muller
Photography credit to Elliana Allon

Brittany Young
Story credit to Brittany Young
Photography credit to
Carrie Rose Photography

Catherine Belknap
Story and photography credit to
Catherine Belknap, @catandnat

Catherine Giudici Lowe
Story and photography credit
to Catherine Giudici Lowe,
@catherinegiudici

Cherie J. Cohen
Story and photography
credit to Cherie J. Cohen

Cheska Sia
Story and photography credit
to Cheska Sia, @chiasmusqueen

Cheznay Dones
Story credit to Cheznay Dones
Photography credit to
Devynn Leanne Photography

Christy Turlington
Story and photography credit
to Christy Turlington

Corrine McPherson
Story credit to Corrine McPherson
Photography credit to Heather White

Cynthia Andrew
Story and photography credit
to Cynthia Andrew, @simplycyn

Danielle DuBoise
Story and photography credit to
Danielle DuBoise, CEO of Sakara

Desiree Fortin
Story and photography
credit to Desiree Fortin

Domino Kirke-Badgley
Story credit to Domino Kirke-Badgley,
Co-Founder and Co-Director
of Carriage House Birth
Photography credit to
Pamela Hanson

Donna Duarte-Ladd
Story credit to Donna Duarte-Ladd
Photography credit to
Nina Gallo Photography

Elizabeth Flynn
Story and photography
credit to Elizabeth Flynn

Elizabeth Whaley
Story and photography
credit to Elizabeth Whaley

Emily Freiburger
Story credit to Emily Freiburger
Photography credit to Geneviève
Charbonneau, Fuze Reps

Erica Bayley
Story credit to Erica Bayley
Photography credit to Geneviève
Charbonneau, Fuze Reps

Erica Domesek
Story and photography
credit to Erica Domesek

Erika Spring
Story and photography
credit to Erika Spring

Eva Longoria
Story and photography
credit to Eva Longoria

Gabriella Woodward
Story credit to Gabriella Woodward
Photography credit to Zoe Elkington

Gabrielle Union Wade
Story and photography
credit to Gabrielle Union Wade

Gaia Picciolini
Story credit to Gaia Picciolini
Photography credit to
Arnoud Verrips

Garcelle Beauvais
Story and photography
credit to Garcelle Beauvais

Georgia Burns
Story credit to Georgia Burns
Photography credit to Hannah
Davison, HZD Photography

Hannah Bronfman
Story and photography credit to
Hannah Bronfman, Founder of
HBFIT, @HannahBronfman

Hannah Judah
Story and photography
credit to Ally Zonsius

Heather White
Story credit to Heather White
Photography credit to Mary
Catherine Hamelin

Jaime Cline
Story credit to Jaime Cline
Photography credit to Lauren
Craney, Memories by Lauren

Jamie-Lynn Sigler
Story and photography
credit to Jamie-Lynn Sigler

Jasmine Pachar
Story and photography credit to
Jasmine Pachar, @jasmine.pachar

Jemima Kirke
Story credit to Jemima Kirke, citing
D. H. Lawrence's *The Rainbow*
Photography credit to Jemima Kirke

Jenny Bird
Story and photography
credit to Jenny Bird

Jenny LeFlore
Story and photography credit to
Jenny LeFlore, @mamafreshchi

Jessica Hall
Story and photography credit
to Jessica Hall, @jessicalaure_l

Jessica Zucker
Story credit to Jessica Zucker,
@ihadamiscarriage
Photography credit to Elliana Allon

Jillian Harris
Story credit to Jillian Harris
Photography credit to
Krista Evans Photography

Joanna Griffiths (Cover)
Photography credit to
Geneviève Charbonneau, Fuze Reps

Joanna Griffiths
Story credit to Joanna Griffiths,
Founder of Knix
Photography credit to @joannaknix

Joanne Ferguson
Story credit to Joanne Ferguson
Photography credit to
Steven Roberts Fine
Art Photography

Kara Kasser
Photography credit to Devynn
Leanne Photography

Karen Greve Young
Story credit to Karen Greve Young
Photography credit to
Maria Lise Young Photography

Kat de Naoum
Story credit to Kat de Naoum
Photography credit to
Alexandros Kalogiannakis

Credits

Katie Watkins
Story and photography
credit to Katie Watkins

Kemi T. Akinyemi
Story and photography
credit to Kemi T. Akinyemi

Kristen Bell
Story and photography
credit to Kristen Bell

Kristen Watts Shelton
Story and photography
credit to Ally Zonsius

Kristina Zias
Story and photography credit
to Kristina Zias, @kristinazias

Lauren McPhillips
Story and photography
credit to Lauren McPhillips,
@thisrenegadelove

Leah Goldglantz
Story and photography
credit to Leah Goldglantz,
@leahsplate

Libby King
Story credit to Libby King
Photography credit to Megan Ghiroli

Lindsey Bliss
Story and photography credit
to Lindsey Bliss, Co-Founder of
Carriage House Birth

Lindsey Van Cleave
Story and photography
credit to Lindsey Van Cleave

Liz Plosser
Story and photography
credit to Liz Plosser

Lori Yerry
Story and photography
credit to Lori Yerry Photography

Maeonya R. Watson
Story and photography
credit to Maeonya R. Watson

Mante Molepo
Story credit to Mante Molepo
Photography credit to tia
photography, Christina MacPherson

Mariana Azevedo de Oliveira
Story credit to Mariana
and Theodore
Photography credit to Geneviève
Charbonneau, Fuze Reps

Marie-Lou Gagnon
Story credit to Marie-Lou Gagnon
Photography credit to Heather White

Meg Boggs
Story and photography
credit to Meg Boggs,
@meg.boggs

Meg MacPherson Morine
Story and photography credit
to Meg MacPherson Morine,
@phitphysiomeg

Melissa Duren Conner
Story and photography
credit to Melissa Duren Conner

Mia Matias
Story credit to Mia Matias
Photography credit to Nestor Matias

Hon. Michaelle C. Solages
Story and photography credit
to Hon. Michaelle C. Solages

Natalie Telfer
Story and photography credit
to Natalie Telfer, @catandnat

Natalie Uhling
Story and photography
credit to Natalie Uhling

Neram Nimindé (Cover)
Photography credit to
Neram Nimindé, @neramniminde

Neram Nimindé
Story credit to Neram Nimindé,
@neramniminde
Photography credit to Manuela
Montañez Guerra, @manuelamg

Nettie Lile
Story credit to Nettie Lile
Photography credit to Tiffany
Hernandez with Tiffany Marie
Photography of Richmond, VA

Nicole Keshishian Modic, JD
Story credit to Nicole Keshishian
Modic, JD, @kalejunkie
Photography credit to
Nicole Keshishian Modic

Nyakio Grieco
Story and photography
credit to Nyakio Grieco

Pascale Hunt
Story credit to Pascale Hunt
Photography credit to
Lyndsey Gavin

Quisha Freeman
Story and photography
credit to Quisha Freeman

Rebecca Huang
Story credit to Rebecca Huang
Photography credit to Emily Neill

Rebecca Minkoff
Story and photography
credit to Rebecca Minkoff

Rebecca Ringquist
Story and photography
credit to Kimberly Kimble,
Rushes + Waves

Ricki Lake
Story and photography
credit to Ricki Lake

Rocky Barnes
Story and photography
credit to Rocky Barnes

Sadie Cotton
Story credit to Sadie Cotton
Photography credit to Mark Cotton

Samantha Huggins
Story credit to Samantha Huggins
Photography credit to Annabel Clark

Sarah Komers
Story credit to Sarah Komers,
Mom Culture
Photography credit to Sarah Komers

Sarah Michelle Gellar
Story and photography credit
to Sarah Michelle Gellar

Sarah Nicole Landry
Story and photography
credit to Sarah Nicole Landry,
@thebirdspapaya

Sazan Hendrix
Story and photography
credit to Sazan Hendrix, @sazan

Shanola Hampton
Story and photography
credit to Shanola Hampton,
@shanolahampton

Shekiera Bright
Story and photography
credit to Shekiera Bright

Shelby Rabara
Story and photography
credit to Shelby Rabara

Sophia Dhrolia
Story and photography
credit to Sophia Dhrolia

Stevie McKulsky
Story credit to Stevie McKulsky
Photography credit to Heidi Daniels

Taylor Dini
Story and photography credit
to Taylor Dini, @taylordini

Teiah Lucas
Story credit to Kirstie Perez
Photography credit to
Kirstie Perez and Teiah Lucas

Tina Tyrell
Story and photography credit to
Tina Tyrell, Photographer, NYC

Tracey Cooke
Story and photography
credit to Tracey Cooke

Tre Watley
Story credit to Tre Watley
Photography credit to
Lottie Dottie Imagery

Valeria Lipovetsky
Story and photography
credit to Valeria Lipovetsky,
@valerialipovetsky

Violette Serrat
Story credit to Violette Serrat
Photography credit to Steven Pan

Vivian Kwan
Story and photography
credit to Vivian Kwan, @lifedevivi

Yessenia Morales
Story and photography
credit to Yessenia Morales

First published in the United States of America in 2021 by
Rizzoli International Publications, Inc.
300 Park Avenue South
New York, NY 10010
www.rizzoliusa.com

Publisher: Charles Miers
Editor: Daniel Melamud
Design: Brankica Harvey & Ken Deegan
Proofreader: Megan Conway
Production Director: Maria Pia Gramaglia

Library of Congress Control Number: 2021931114
ISBN-13: 978-0-8478-6960-2

2021 2022 2023 2024 / 10 9 8 7 6 5 4 3 2 1
Printed in Italy

Visit us online:
Facebook.com/RizzoliNewYork
Twitter: @Rizzoli_Books
Instagram.com/RizzoliBooks
Pinterest.com/RizzoliBooks
Youtube.com/user/RizzoliNY
Issuu.com/Rizzoli